IMAGES
of America

RANCHO SANTA
MARGARITA

D1249273

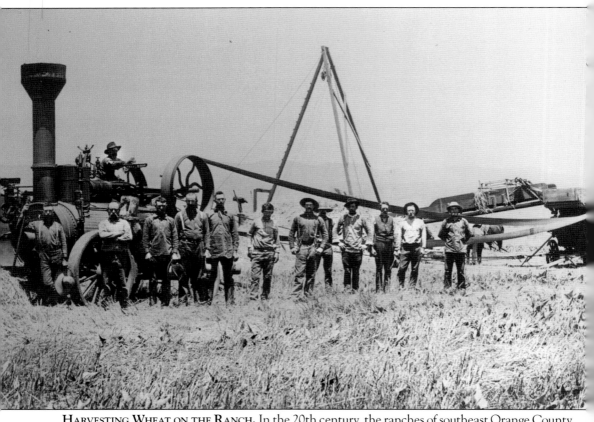

HARVESTING WHEAT ON THE RANCH. In the 20th century, the ranches of southeast Orange County were prosperous with the harvesting of wheat. In this photograph, ranch workers are posing after a busy day separating grain from husks. (Courtesy of San Juan Capistrano Historical Society.)

ON THE COVER: THE RANCH HERITAGE. Before the tract homes, reality shows, and city parks, Rancho Santa Margarita was part of a thriving ranch. This picture depicts some of the many eccentric figures who worked various jobs on the ranch. (Courtesy of San Juan Capistrano Historical Society.)

IMAGES
of America

RANCHO SANTA MARGARITA

Dr. Michael A. Moodian

ARCADIA
PUBLISHING

Published by Arcadia Publishing
Charleston SC, Chicago IL, Portsmouth NH, San Francisco CA

Printed in the United States of America

Library of Congress Control Number: 2009932658

For all general information contact Arcadia Publishing at:
Telephone 843-853-2070
Fax 843-853-0044
E-mail sales@arcadiapublishing.com
For customer service and orders:
Toll-Free 1-888-313-2665

Visit us on the Internet at www.arcadiapublishing.com

*To my mother, Phyllis Moodian, my father,
Armand Moodian, and Margaret Minnis*

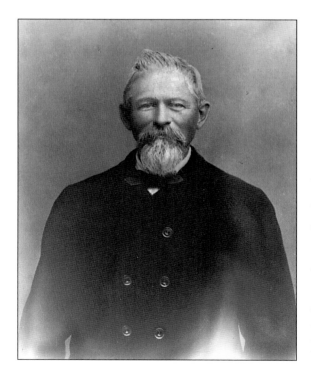

RICHARD O'NEILL SR. O'Neill and James Flood purchased the ranch in 1882. Flood provided the capital, and O'Neill Sr. would work for his share as a ranch manager and cattleman. He was the first of a lineage of family members who would own the land and help develop it into the communities that exist today. The family motto was a simple one: "Take care of the land and the land will take care of you." (Courtesy of MCB Camp Pendleton Archives.)

Contents

Acknowledgements 6

Introduction 7

1. Juaneño, Spanish, and Mexican Rule of the Land 9

2. A Thriving Ranch 23

3. The O'Neill Family Legacy 89

4. The Development of an Urban Village
 and the City Today 107

Acknowledgments

It has been a wonderful experience to have the opportunity to tell the story of southeast Orange County and the City of Rancho Santa Margarita. This book would not have been possible without the gracious help of many people. Special thanks to Buck Bean of Rancho Mission Viejo, Don Tryon and Wick Lobo of the San Juan Capistrano Historical Society, Faye Jonason of Marine Corps Base Camp Pendleton, and Richard Reese of the Rancho Santa Margarita Historical Society. Arcadia Publishing is a wonderful company to work with. Thank you to Debbie Seracini, Devon Weston, and Scott Davis. I would also like to express my appreciation to Jerome Baumgartner, author of *Rancho Santa Margarita Remembered,* and Jim Sleeper, author of some of the historical documents at Rancho Mission Viejo. The work of both men was instrumental as I conducted the research for this book.

I would also like to thank my friends and family throughout the world for their support, notably, my nieces and nephew, Kasie, Kepano, Stephenie, and Kaili; my brother Keith; the Almeida family; the Beckman family; Gov. Michael Dukakis; Dr. Charles Fischer; the Minnis family; and Frank Nainoa.

Thank you to the fellow faculty, staff, and students at Brandman and Chapman Universities. Additionally, thank you to the faculty of the Graduate School of Education and Psychology at Pepperdine University and the communications and sociology departments at California State University, Fullerton.

Special thanks to you, the reader of this book. Please be in touch with your feedback, comments, and stories. Visit my Web site, www.moodian.com, for my contact information.

All photographs used in this book belong to the author, unless otherwise noted.

INTRODUCTION

Rancho Santa Margarita has a rich history that traces back to the Native American, Spanish, Mexican, and U.S. American roots of the state of California. The original inhabitants of south Orange County were members of the Acjachemen Nation (renamed by the Spanish missionaries and known today as the Juaneño). The indigenous group established villages of 50 to 250 inhabitants each throughout Orange County. In May 1769, land and sea parties of the Portola-Serra expedition met in present-day San Diego in what would mark the start of the Spanish occupation of Alta California. Nearly three months later, on July 20 (the holy day of St. Margaret), Portola and his men arrived in present-day Camp Pendleton. To honor the day, the land was baptized in the name of Santa Margarita. Soon thereafter, on July 24 and 25, Portola's group (composed of Gaspar de Portola, Fr. Juan Crespi, 63 Spanish soldiers, and 100 mules) camped on a mesa near the base of the Saddleback Mountains, which they named San Francisco Solano. In this area, one of the soldiers lost his blunderbuss (or Trabuco); thus, the "Trabuco" name would be a fixture of various parts of the area in the years to come. The men proceeded to open the first overland trail through California, an area that today is part of O'Neill Park's Arroyo Trabuco Wilderness Trail in Rancho Santa Margarita. Portola's expedition of 1769 marked the first recorded contact between members of the indigenous group, Spanish soldiers, and Franciscan padres. The land was soon under Spanish control when the king of Spain laid claim to the Californias. When Mission San Juan Capistrano was created, the Franciscans used numerous ranches for mission-branded cattle to graze. Present-day Rancho Santa Margarita was one of the primary locations for this activity. In 1818, Mission San Juan Capistrano was attacked by a band of Argentinean pirates led by Hippolyte de Bouchard. The treasures of the mission were transported for safekeeping by the padres to an adobe (known as the Serrano Adobe) many miles away in a location that lies in present-day O'Neill Park. The legend states that three chests were buried near the adobe. Most assume that they were recovered, though there are tales that imply otherwise. Rumors of maps that lead to treasure chests persist, yet nothing has ever publicly been proven conclusive. The adobe on Trabuco Mesa was the largest of the mission's outposts. Records indicate that it was built in 1806. Church records indicate that the mesa at the time was a horse farm, with 1400 mustangs bearing the CAP brand. In 1819, the mission's ranches reached their peak with 14,000 cattle and 16,000 sheep. The Serrano Adobe housed many notable guests, including landowner Santiago Arguello in 1841, Mexican governor Pio Pico (who was hiding from U.S. American troops) in 1846, and Basque sheepherders from 1860 to 1901.

California was a province of Mexico in 1822, and Pio and Andres Pico combined their ranches to form Rancho Santa Margarita y Las Flores. When Pio Pico was governor of California, Englishman John (Don Juan) Forster, Pico's brother-in-law, purchased numerous pieces of land throughout Southern California, notably Mission San Juan Capistrano, Rancho Trabuco, Rancho Mission Viejo, and Rancho Santa Margarita y Las Flores (see the map on page 24). Rancho Mission Viejo and Rancho Trabuco were combined to take the Rancho Mission Viejo name. In return for the

land, Pico's land sales paid off his gambling debts. Forster called Rancho Trabuco "La Victoria," and by 1864, after California was part of the United States, Forster added Pico's San Diego estates to his properties in south Orange County and dedicated Plano Trabuco to wool raising. In 1882, Irishman Richard O'Neill Sr. and James Flood purchased the three adjoining ranches—spanning Aliso Creek in present-day south Orange County to present-day Oceanside in north San Diego County. Flood provided the money for the transaction while O'Neill worked his half as an expert cattleman and resident manager. Under O'Neill's supervision, the adjoining ranches were prosperous with cattle and wheat. In 1907, James L. Flood, son of the cofounder, conveyed his half-interest in the land to O'Neill Sr. Soon thereafter, Jerome O'Neill, son of O'Neill Sr., would take ownership of the ranches.

In 1923, the sons of Flood and O'Neill founded the Santa Margarita Company (also known as Santa Margarita Ranch, Inc.) The company drove a substantial increase in the size of the ranches' agricultural operations. The Plano Trabuco also served as the setting for numerous silent movies. Three years later, both men would pass away, and in 1939, the Santa Margarita Company was discontinued. The Flood and Baumgartner (Mary O'Neill Baumgartner was the sister of Jerome O'Neill) families took control of Rancho Santa Margarita y Las Flores. Richard O'Neill Jr. (the younger brother of Jerome O'Neill) maintained control of Rancho Mission Viejo and Rancho Trabuco.

In February 1942, the U.S. federal government announced that they were taking possession of Rancho Santa Margarita y Las Flores to build the largest marine base in the nation, Marine Corps Base Camp Pendleton. During parts of the 1940s and 1950s, significant portions of present-day Rancho Santa Margarita were used as a bombing range for troops from Marine Corps Air Station El Toro. Many parts of the Trabuco Bombing Range now comprise O'Neill Regional Park, the Tijeras Creek Golf Course, and various other commercial and residential development areas.

The parcels known as Rancho Trabuco and Rancho Mission Viejo were combined to take the Rancho Mission Viejo name. In the 1960s, the grandson and great-grandson of Richard O'Neill Sr., Richard J. O'Neill, and Anthony Moiso, started the Mission Viejo Company to transform a major portion of their land into a master-planned community of Mission Viejo. On May 30, 1985, ground was broken on the 5,000-acre Plano Trabuco area for the development of the urban village of Rancho Santa Margarita.

The town of Rancho Santa Margarita was incorporated as the 33rd city of Orange County on January 1, 2000. Today the city, primarily composed of master-planned communities, has a population of nearly 50,000. The initial city council was composed of Debra Lewis (the first mayor of the city), Cara Gamble, Neil Blais, Gary Thompson, and Jim Thor. In addition to Jerry Holloway and Anthony Beall, all five of the inaugural council members have served the city as mayor for at least one term. Though Rancho Santa Margarita is one of the youngest cities in Orange County, it has a fascinating history that will be explored in greater detail throughout this book.

Special note: As you are reading this book, Rancho Santa Margarita y Las Flores refers to the area that is Marine Corps Base Camp Pendleton today. Rancho Santa Margarita refers to the area that is the current city of that name in southeast Orange County.

One

JUANEÑO, SPANISH, AND MEXICAN RULE OF THE LAND

GASPAR DE PORTOLA. The governor of Las Californias from 1768 to 1770, Portola led a Spanish expedition through the area that is the Trabuco Arroyo Wilderness Trail in Rancho Santa Margarita. A padre from the group christened the area San Francisco Solano. Years later, the mesa would be chosen for a mission, but it would be built in present-day San Juan Capistrano instead. (Courtesy of MCB Camp Pendleton Archives.)

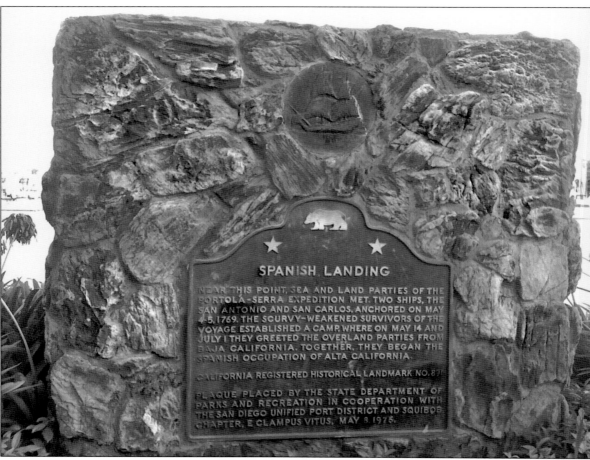

THE CONQUEST OF ALTA CALIFORNIA. The journey began in 1769, where parties from the Portola-Serra expedition met in present-day San Diego to begin the conquest of Alta California. Previously, Serra had come from Baja California, where he was administrating the missions. The Portola expedition traveled north from this location with the intention of establishing Franciscan missions throughout California.

JUANEÑO LIVING STRUCTURES.
The Juaneños lived in shelters such as these, known as *kiitchas*, before the Spanish arrived. The housing units were made of willow branches and tule leaves. They were used for sleeping or for refuge during poor weather. When a *kiitcha* was worn out, it was burned, and a replacement was erected in its place.

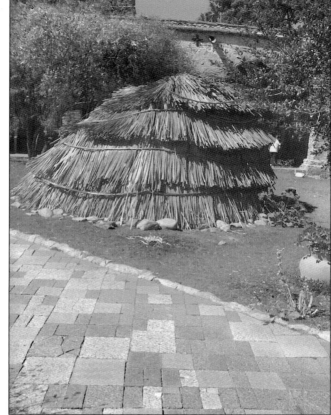

LAS FLORES ESTANCIA, 1850.
This location was significant for those who traveled north from the southern portion of Alta California. The structure was built by Fr. Antonio Peyri in 1823 and served as lodging for travelers between Mission San Luis Rey and Mission San Juan Capistrano. (Courtesy of MCB Camp Pendleton Archives.)

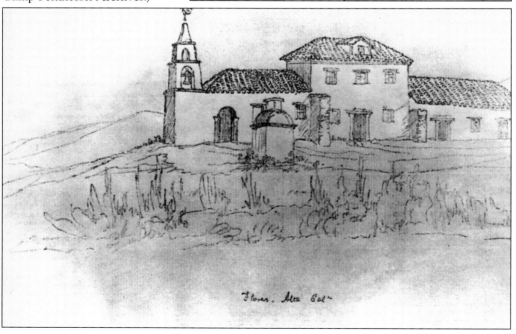

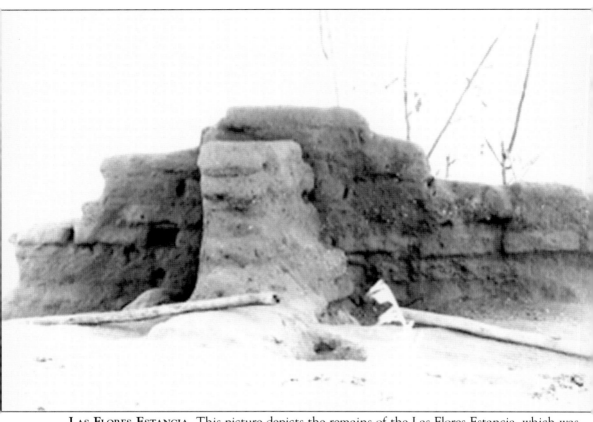

LAS FLORES ESTANCIA. This picture depicts the remains of the Las Flores Estancia, which was located in the Rancho Santa Margarita y Las Flores area. The area was also known as "Los Rosales," "San Pedro de Las Flores," and "Ushmai" (by Native Americans). On July 22, 1769, the first recorded baptisms in Alta California occurred on the banks of a nearby stream. (Courtesy of MCB Camp Pendleton Archives.)

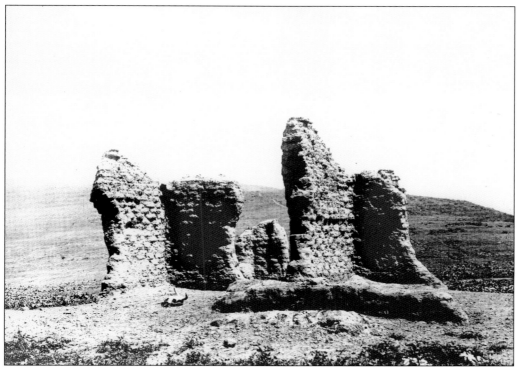

LAS FLORES ESTANCIA. The building that was once the Las Flores Estancia turned into ruins over the years. The area became a National Historic Landmark in 1968. Rancho Santa Margarita y Las Flores, or "Saint Margaret and the Flowers," was one of the first places in California to bear a Spanish name. (Both courtesy of MCB Camp Pendleton Archives.)

LAS FLORES ESTANCIA. The original name that Gaspar de Portola gave to Las Flores (in present-day San Diego) was "La Canada de Santa Pragedis de los Rosales." The adjacent corral was site of a battle between Juan Bautista Alvarado and Carlos Antonio Carrillo for the governorship of Alta California in 1838. (Courtesy of MCB Camp Pendleton Archives.)

FIRST BAPTISM. As Portola's expedition traveled north, Padre Francisco Gomez performed the first Christian baptism in Alta California. During the same expedition, a padre of the expedition baptized a large parcel of land in present-day northwest San Diego County on the holy day of Saint Margaret. The land blessed in the name of Santa Margarita would eventually become known as Rancho Santa Margarita y Las Flores. (Courtesy of MCB Camp Pendleton Archives.)

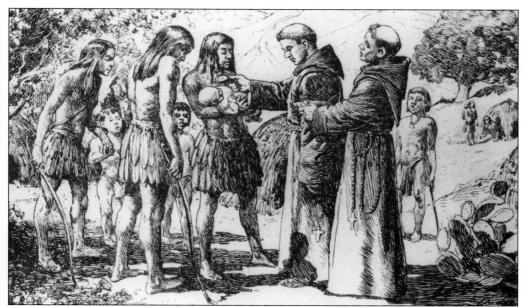

LA CHRISTIANITA. Here is an artist depiction of the event that now marks the geographic area as La Christianita near the border present-day north San Diego County and south Orange County. A Native American baby is being baptized into the Roman Catholic Church. (Courtesy of Rancho Mission Viejo.)

CATTLE RANCH CROSS. In accordance with Spanish Catholic tradition, a cross was placed at the top of a hill at every cattle ranch. Rancho Santa Margarita y Las Flores had one, as did various ranches throughout California. From the tops of such hills, one could enjoy beautiful views of the ranch house and surrounding areas. (Courtesy of MCB Camp Pendleton Archives.)

SAN FRANCISCO SOLANO. On July 24 and 25, 1769, the men of the Portola Expedition camped at this location, which was christened "San Francisco Solano." One of Portola's soldiers lost his trabuco, which gave rise to variations of the "Trabuco" name throughout the region over the years that would follow. The "Trabuco" moniker is a fixture of southeast Orange County, with location names such as Trabuco Canyon, the Trabuco Mesa/Plano Trabuco, Trabuco Hills High School, and Trabuco Road. Five years later, the Spanish viceroy for Mexico dictated that a mission be built on or near this location. Instead, Mission San Juan Capistrano would be established 9 miles away due to a lack of water in the mesa.

SAN FRANCISCO SOLANO. The area that the men camped in was a flat mesa. Remarkably, this is an area of incredible historical significance, particularly when one considers the connection to Portola, Pio Pico, and the legend of hidden treasures that may exist somewhere nearby. This location can be accessed by entering O'Neill Park at the gate that is located near the Tijeras Creek Golf Course.

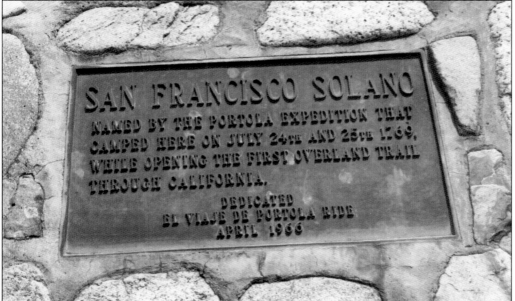

MARKER OF PORTOLA EXPEDITION. This marker is set in the location of the campsite and christening of San Francisco Solano (for the 16th-century Spanish-born saint, a missionary to Peru). This was part of the opening of the first overland trail through California, and the plain was marked for a future mission. The trail on this mesa lies parallel with present-day Alicia Parkway. The Acjachemen Indians referred to the mesa as Alume, which meant "to raise the head in looking upward." Such was a reference to the peaks of the Saddleback Mountains, which they referred to as Kalawpa. Juan Bautista Anza and his Mexican expedition traveled through the area on February 8, 1776. The records of the chaplain stated that the area was referred to as Trabuco "because the first expedition lost a blunderbuss here." On November 11, 1776, Father Serra escaped an attack by local Native Americans. In his report, an aide described the attack as occurring "en el paraje el Trabuco." (Courtesy of Rancho Mission Viejo.)

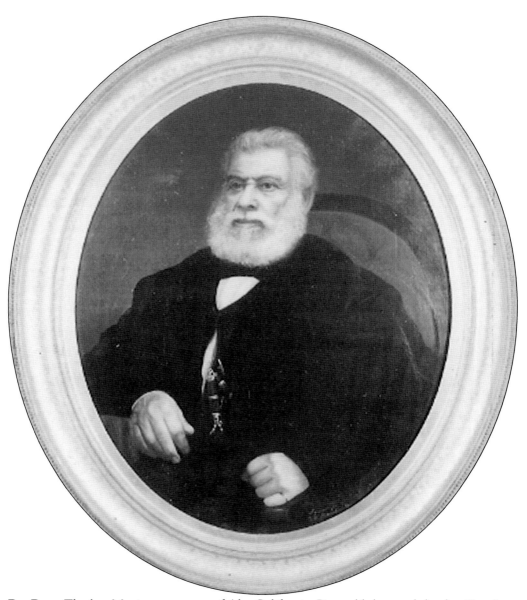

Pɪᴏ Pɪᴄᴏ. The last Mexican governor of Alta California, Pico sold the ranch land to Don Juan Forster, his brother-in-law. He hid in the Serrano Adobe (near the San Francisco Solano area) in 1846 in an attempt to elude American troops during the Mexican-American War. In the years that followed, Pico and Forster were engaged in a complicated legal battle over the land deal, one in which Forster would prevail. (Courtesy of MCB Camp Pendleton Archives.)

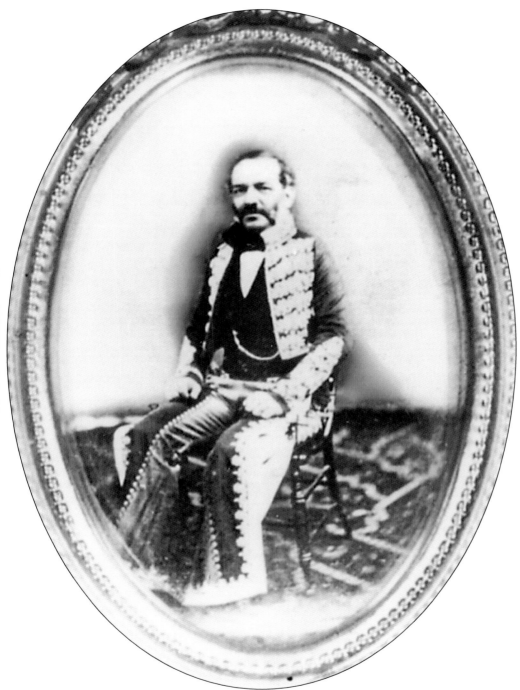

Andres Pico. He was the brother of Pio Pico who commanded the Mexican forces in opposition to the United States during the Mexican-American War. After California became a part of the United States, he served as a state senator, representing San Diego from 1860 to 1861. (Courtesy of MCB Camp Pendleton Archives.)

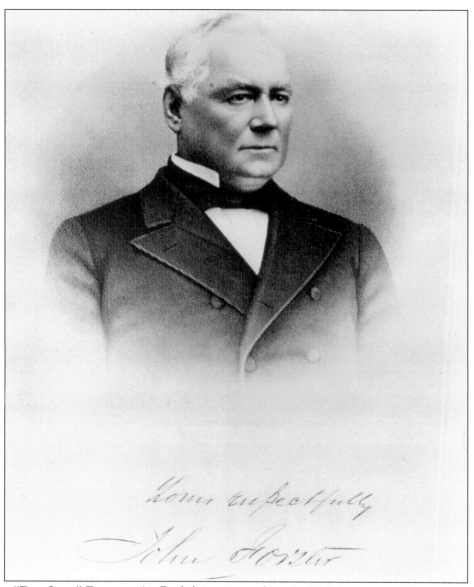

JOHN "DON JUAN" FORSTER. An English immigrant born in 1815, Forster would become one of California's largest landowners. He traveled to Mexico from England at the age of 17 to work on one of his uncle's ships. In 1836, he became a Mexican citizen and worked as a shipping agent in San Pedro. In 1837, he married Doña Ysidora Pico, sister of Pio Pico. Through his connections to the governor, Forster was able to purchase numerous pieces of land throughout present-day Orange and San Diego Counties. By 1864, Forster owned Rancho Trabuco, Rancho Mission Viejo, and Rancho Santa Margarita y Las Flores. The purchase of Rancho Santa Margarita y Las Flores made Forster the largest landowner in California, with property exceeding 200,000 acres. Forster and his family moved to Rancho Santa Margarita y Las Flores in 1864 and greatly expanded the ranch house. The land would eventually be sold to James Flood and managing partner Richard O'Neill Sr. Details of the ranch house and O'Neill family legacy will be explored in greater detail in the chapters that follow. (Courtesy of Rancho Mission Viejo.)

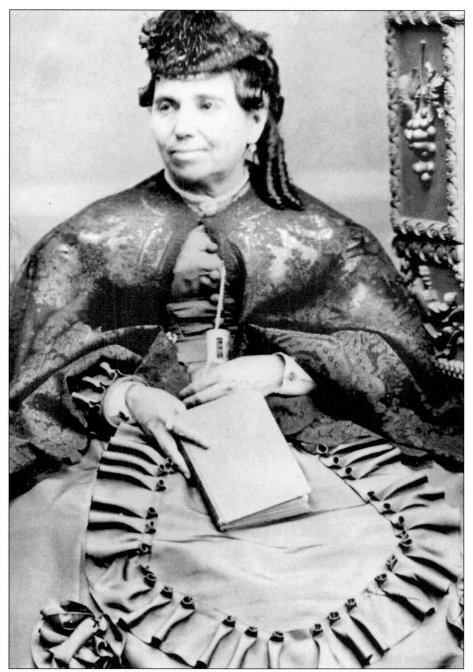

DOÑA YSIDORA FORSTER (PICO). Ysidora Pico was the sister of Pio and Andres Pico who married John "Don Juan" Forster. At the time, foreigners to Mexico had to complete multiple steps to intermarry, including becoming a citizen of Mexico (which included converting to Catholicism) and applying for approval from the governor. After the Englishman Forster and Pico married, they became one of the most prominent couples in California through their numerous land holdings. (Courtesy of Rancho Mission Viejo.)

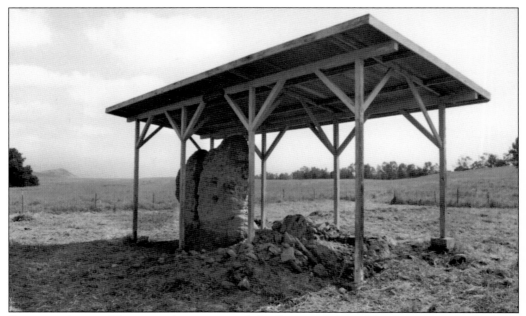

SERRANO ADOBE. These are the remains of the Serrano Adobe (also known as the Trabuco Adobe). The treasures of Mission San Juan Capistrano were reportedly transported here (or near here) in 1818 when the mission was under attack by Argentinean pirates. Legends persist of treasure chests buried near the structure, including a story about three chests located within the crotch of a sycamore tree. Pio Pico also hid here to elude invading American troops in 1846. The structure stands behind the marker of the Portola expedition, illustrating the fact that this location served as a temporary home for two pre-U.S. American California governors—Gaspar de Portola, the Spanish governor of Las Californias, and Pico, the last Mexican governor of Alta California. This is the most noteworthy historic landmark in Rancho Santa Margarita. (Both courtesy of Rancho Mission Viejo.)

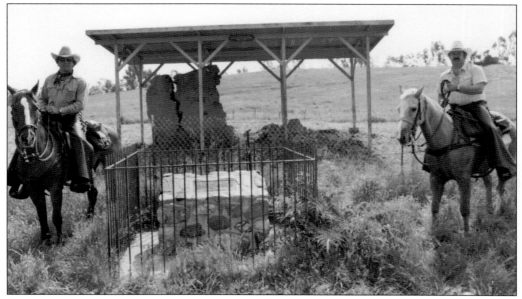

Two

A THRIVING RANCH

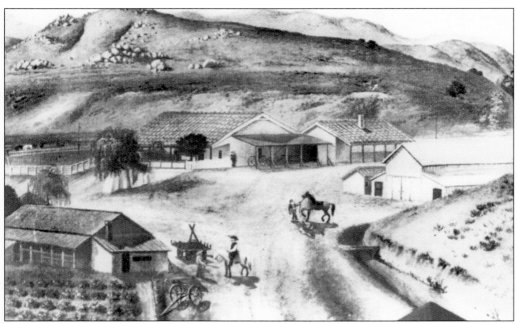

OIL PAINTING OF THE RANCH, 1870S. This oil painting depicts life on the ranch during the 1870s, a period when the land was owned by Don Juan Forster. Governor Alvarado provisionally granted Rancho Santa Margarita to Pio and Andres Pico in 1841. In 1844, Las Flores was added, and in 1864, Pio Pico purchased his brother's interest before Forster became owner of the land. (Courtesy of MCB Camp Pendleton Archives.)

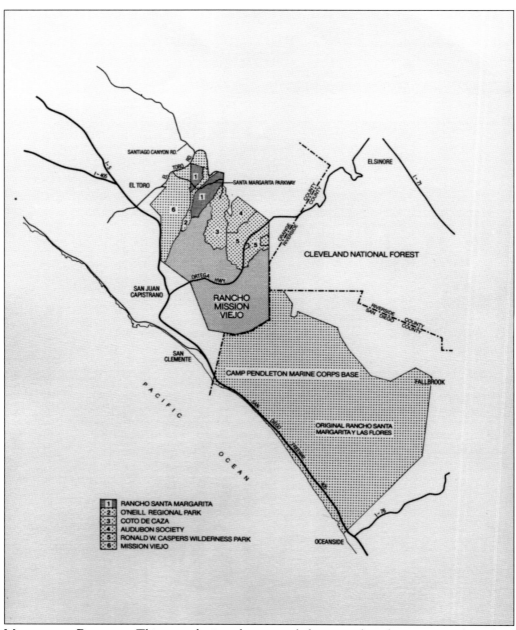

MAP OF THE RANCHES. This map depicts the original three ranches that comprised much of south Orange County and north San Diego County. The original Rancho Santa Margarita y Las Flores is now the Camp Pendleton Marine Corps Base. Much of present-day Rancho Santa Margarita (No. 1 on the map) comprised the north end of Rancho Trabuco. Rancho Mission Viejo and Rancho Trabuco would eventually merge, taking the Rancho Mission Viejo name. These parcels were the ranches of the missionaries of Mission San Juan Capistrano, thus the histories of the cities and towns that now exist in these areas are closely intertwined. (Courtesy of Rancho Mission Viejo.)

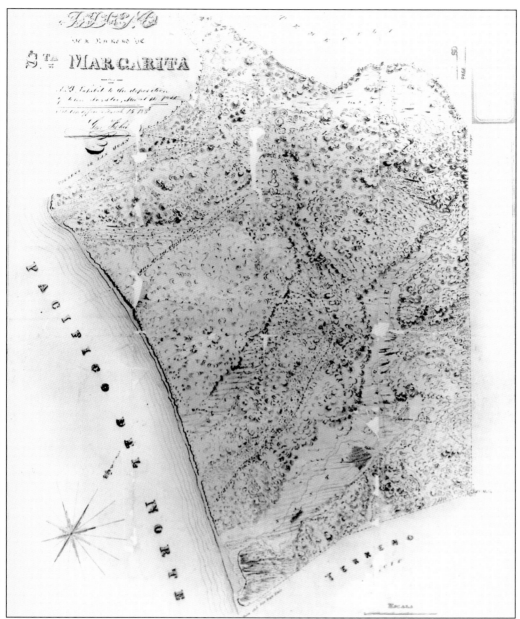

MAP OF RANCHO SANTA MARGARITA Y LAS FLORES. This is one of the original maps of the area encompassing Rancho Santa Margarita y Las Flores. Note the enormity of the land, which comprised a sizeable area in present-day San Diego County. The area contained thousands of horses, cattle, and other livestock. (Courtesy of MCB Camp Pendleton Archives.)

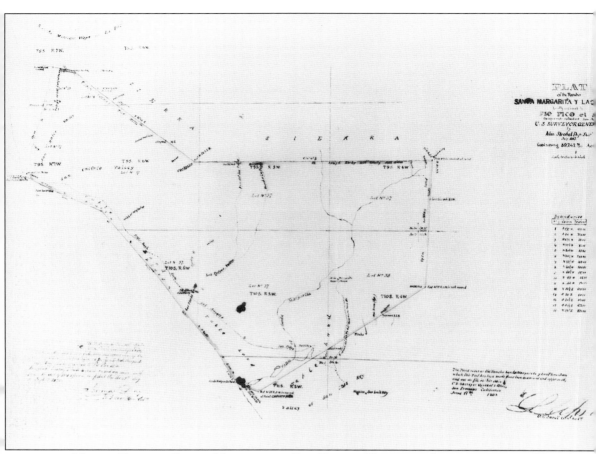

MAP OF RANCHO SANTA MARGARITA Y LAS FLORES. This is another vintage map of Rancho Santa Margarita y Las Flores, the largest of the ranches in today's south Orange County and north San Diego County. Not only was this one of the largest ranches, but it was one of the most significant ranches in California history, with many ties to historical events that shaped modern-day California. (Courtesy of MCB Camp Pendleton Archives.)

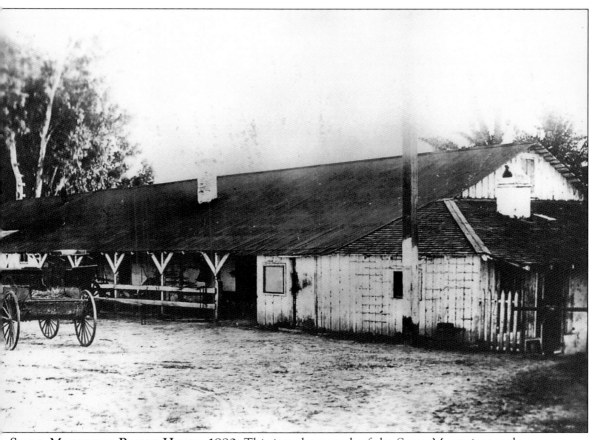

Santa Margarita Ranch House, 1880. This is a photograph of the Santa Margarita ranch house during the time of Don Juan Forster. The lake was washed away in a 1916 flood. The ranch house was built in the mid-1820s and was expanded during Forster's time there. In the late 1800s, there was also a short-lived settlement in the area known as Forster City. Previously, the house was home to Pio Pico. After Forster, members of the O'Neill, Flood, and Baumgartner families resided in the structure before it became property of the federal government and ultimately the residence of Camp Pendleton's commanding general. Forster expanded Pico's modest residence into a beautiful structure featuring 18 rooms and a nice interior patio. Today the ranch house is on the National Register of Historic Places. The chapel on the compound began as a winery in 1810. (Courtesy of MCB Camp Pendleton Archives.)

RANCH HOUSE TOOL SHED AND BLACKSMITH SHOP. The tool shed and blacksmith shop are depicted in this drawing. In 1798, an adobe guard house and corral for the mission was located on the site where the ranch house would be built. (Courtesy of MCB Camp Pendleton Archives.)

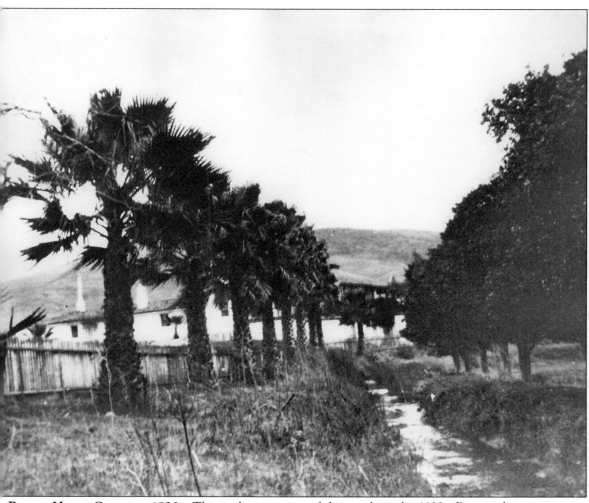

RANCH HOUSE CORRALS, 1920S. This is the east view of the ranch in the 1920s. During this era, the ranch was run by Jerome O'Neill (president of the Santa Margarita Company, referred to by some as Santa Margarita Ranch, Inc.) and James L. Flood. (Courtesy of MCB Camp Pendleton Archives.)

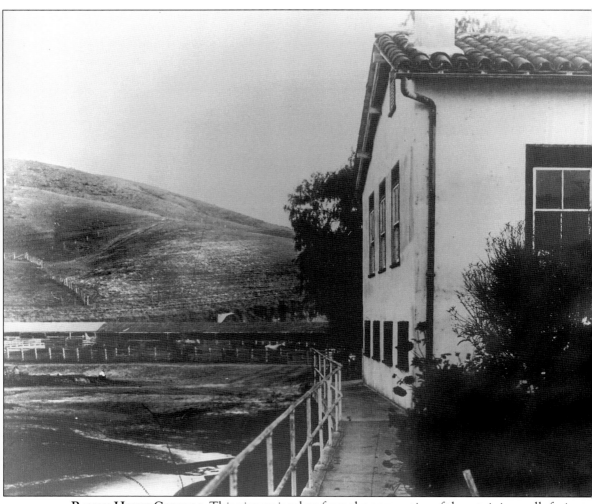

RANCH HOUSE CORRALS. This picture is taken from the perspective of the retaining walls facing east. The ranch house contained a large enclosure for containing livestock. This was a lively and active ranch. (Courtesy of MCB Camp Pendleton Archives.)

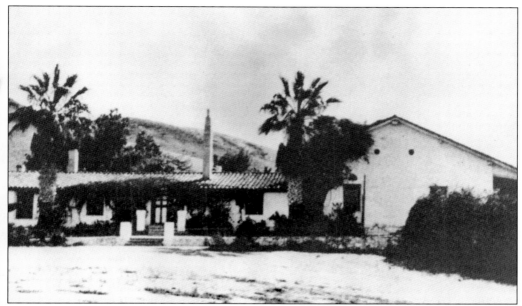

RANCH HOUSE MAIN ENTRANCE (WEST VIEW). This is the main entrance of the structure. Ranch managers from 1926 to 1942 included Charles Hardy, Richard O'Neill Jr., Harry Heffner, and Harry Witman. The house contained what was known as a "big gate," which actually was a set of double doors that led to a covered walkway within the structure. (Courtesy of MCB Camp Pendleton Archives.)

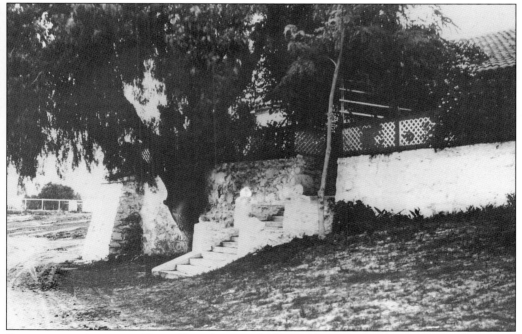

STEPS TO THE ARCH AND BELL. This photograph depicts the steps that lead to the arch and bell of the structure. The house was an architectural gem, built in various phases over the years and preserved well to the present day. (Courtesy of MCB Camp Pendleton Archives.)

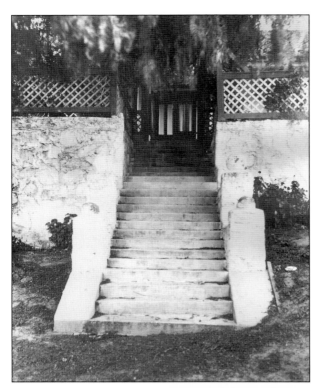

RANCH HOUSE STEPS TO ARCH AND BELL. Here are more photographs of the steps leading to the arch and bell of the building. The house hosted a variety of activities. It was also the residence for visitors of the O'Neill family who would travel to the ranch while vacationing. (Both courtesy of MCB Camp Pendleton Archives.)

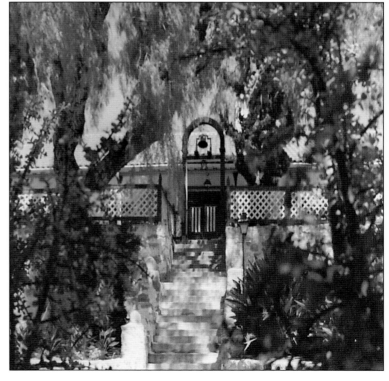

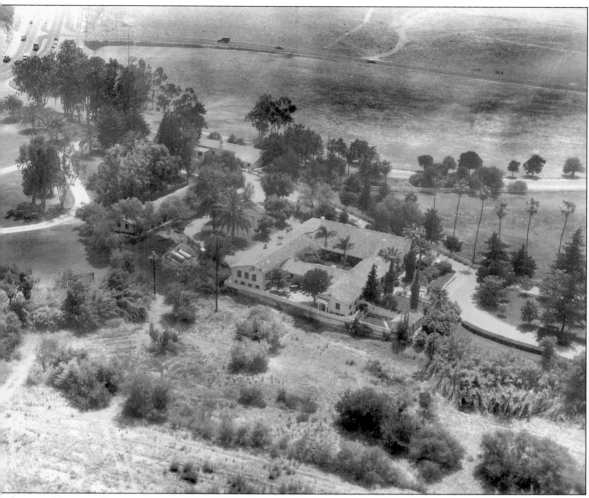

AERIAL VIEW OF RANCH HOUSE, 1955. This is an aerial photograph of the house from 1955. By this time, the land owned by the federal government was operating as Camp Pendleton. When this photograph was taken, the house was likely occupied by either Maj. Gen. John T. Selden or Maj. Gen. George F. Good Jr. (Courtesy of MCB Camp Pendleton Archives.)

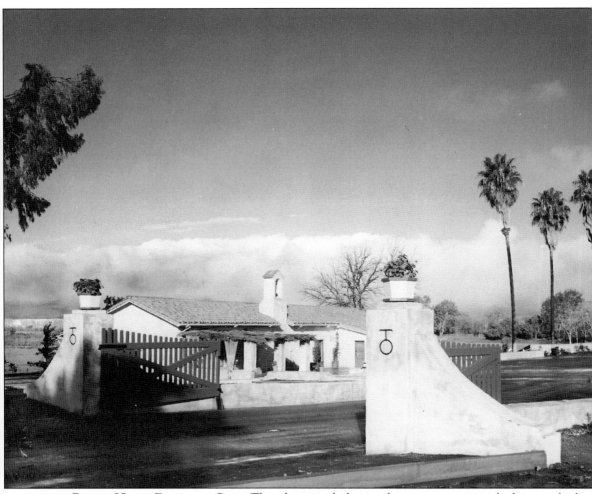

RANCH HOUSE ENTRANCE GATE. This photograph depicts the entrance gate to the house, which served as the commanding general's residence after the land became a marine base. Within the patio of the ranch house was a bougainvillea vine said to be as old as the house. If this was the case, it would have been one of the oldest such vines in California. The patio area was the primary location for entertaining visitors. Note the TO (Texas-Oklahoma) brand on each gate. The symbol is a remnant of large herds of Texas shorthorns that were purchased in the 1800s and 1900s. (Courtesy of MCB Camp Pendleton Archives.)

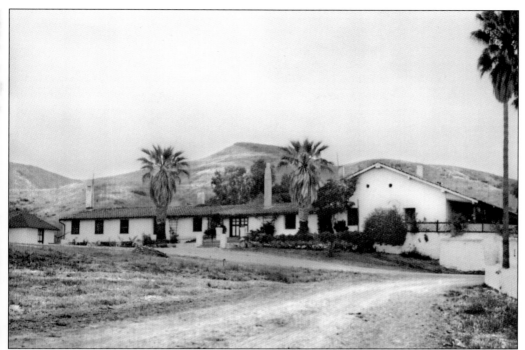

SOUTHEAST VIEW OF THE RANCH HOUSE. These pictures show the southeast views of the structure. Located at the top of the ranch house walls were gigantic beams tied together with rawhide straps. The Marine Corps has done a phenomenal job at maintaining the home to this day. (Both courtesy of MCB Camp Pendleton Archives.)

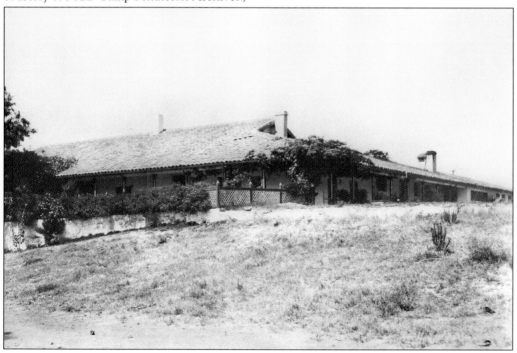

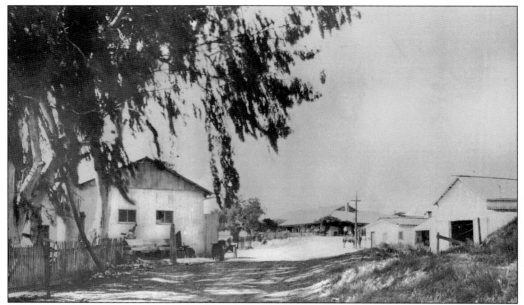

RANCH HOUSE ENTRANCE. The tool shed is in view in this picture of the ranch house entrance. The adobe walls of the interior of the house were incredibly thick so that the roofing of the house could be supported. (Courtesy of the MCB Camp Pendleton Archives.)

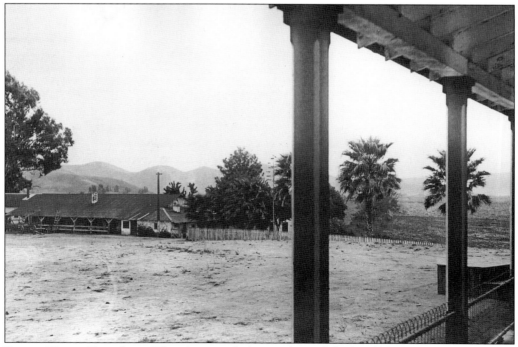

RANCH HOUSE TOOL SHED. This photograph depicts the tool shed and blacksmith shop from the kitchen area. This was an area where highly skilled ranch workers would ply their trade. This area of the house had undergone various changes over the years. (Courtesy of the MCB Camp Pendleton Archives.)

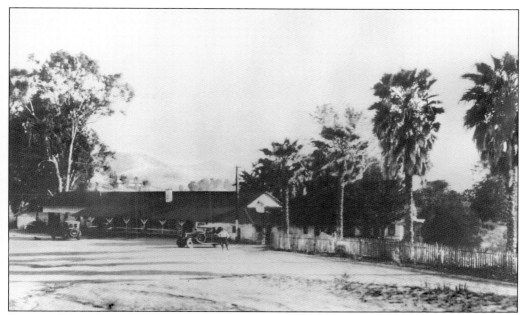

RANCH HOUSE TOOL SHED, 1923. Here is another picture from 1923, the days of the Santa Margarita Company. The blacksmith shop is also in view. During this time, the sons of Flood and O'Neill led the ranch to terrific growth. (Courtesy of the MCB Camp Pendleton Archives.)

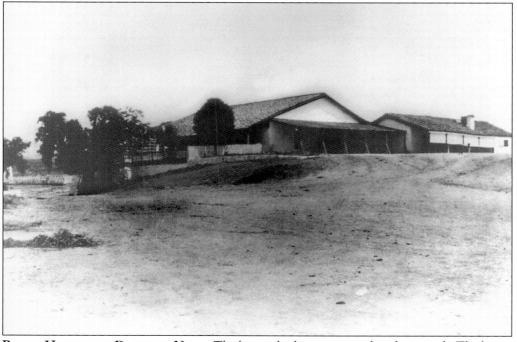

RANCH HOUSE FROM DIFFERING VIEWS. The buggy shed is in view in this photograph. The house was built in several phases, with the original portion being constructed on the lands of Mission San Luis Rey sometime before 1827. The initial structure may have been a one-room adobe used by vaqueros and shepherds. (Courtesy of the MCB Camp Pendleton Archives.)

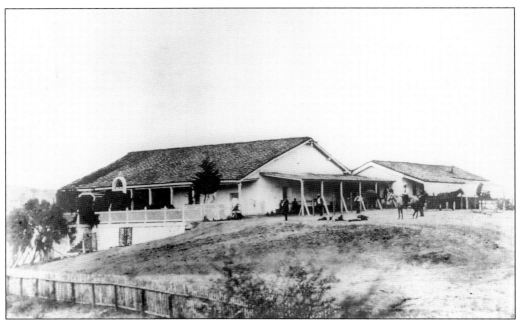

RANCH HOUSE FROM DIFFERING VIEWS. Here are more photographs with differing views, the buggy shed included. Jerome Baumgartner, the great-grandson of Richard O'Neill, provided an intimate and detailed portrait of family life in the ranch house in his book *Rancho Santa Margarita Remembered*. The structure served as ranch headquarters and a home. (Both courtesy of MCB Camp Pendleton Archives.)

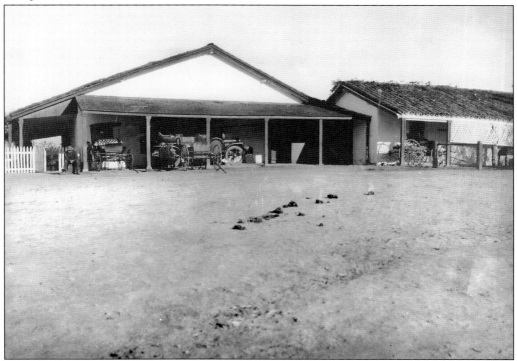

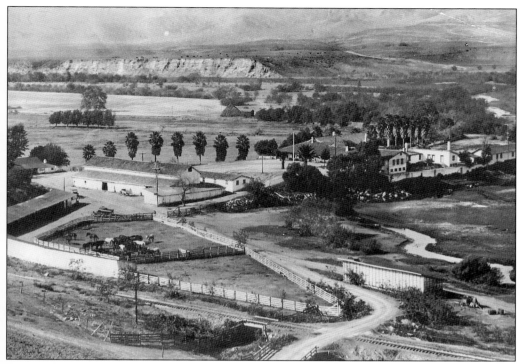

AERIAL VIEW OF RANCH HOUSE WITH BARN AND HORSES, 1917. Here is another photograph taken during the time that Jerome O'Neill oversaw the ranch. The ranch was rich with livestock and various types of horses. (Both courtesy of the MCB Camp Pendleton Archives.)

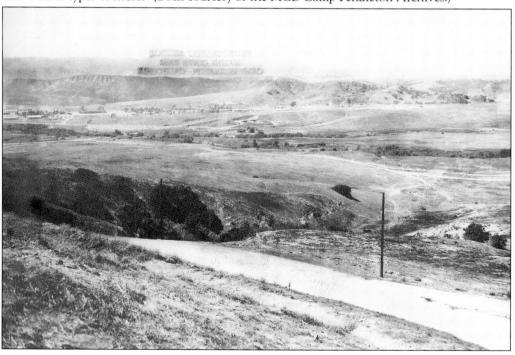

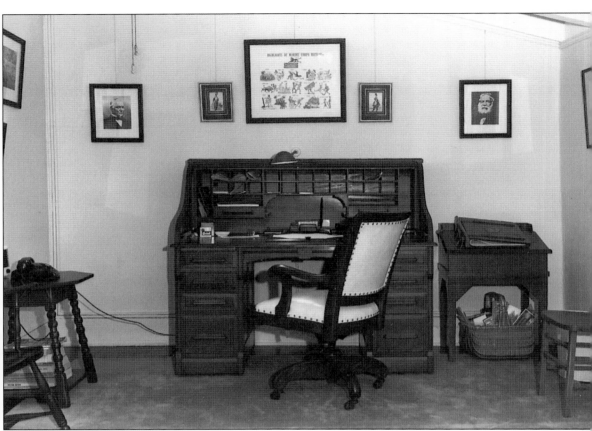

O'NEILL HOUSE STUDY. This is an interior photograph of the ranch's study. The house has been well preserved over the years, and the adobe design of the structure enabled pleasant living conditions despite hot summers or cold winters. (Courtesy of the MCB Camp Pendleton Archives.)

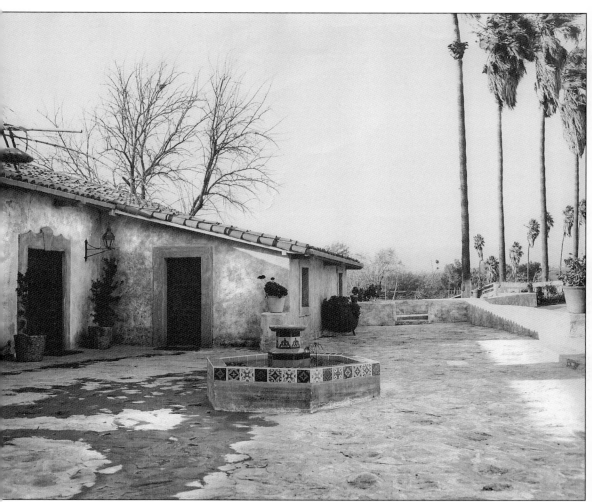

COURTYARD AND CHAPEL FOUNTAIN. The Catholic roots of the area are apparent throughout the historic landmarks in present-day north San Diego County and south Orange County, including the Mission San Juan Capistrano and the christening of the San Francisco Solano in present-day Rancho Santa Margarita. (Courtesy of the MCB Camp Pendleton Archives.)

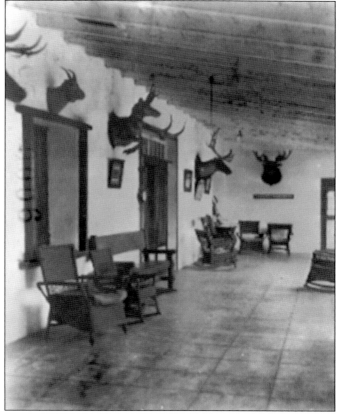

INNER COURTYARD OF RANCH HOUSE. The inner courtyard was one of the favorite places for visitors to the location to meet. The house was square-shaped around an interior courtyard, with rooms that opened to the patio. A covered walkway was located within the square. (Both courtesy of the MCB Camp Pendleton Archives.)

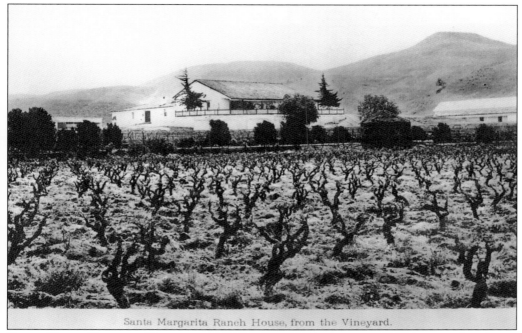

Santa Margarita Ranch House, from the Vineyard.

RANCH HOUSE VIEW FROM VINEYARD, 1880S. This photograph of the ranch house was taken during the Flood/O'Neill Sr. tenure. The son of a butcher, O'Neill Sr. was born in Mitchelstown, County Cork, Ireland. When he relocated to the United States, he first lived in Boston before traveling west during the Gold Rush. He never struck it rich with gold, but his work as a ranch manager established him as one of the prominent figures in the history of south Orange County and north Orange County. The house that he lived in was first described for secularization and tax purposes by Father Peyri of Mission San Luis Rey in 1827. (Courtesy of the MCB Camp Pendleton Archives.)

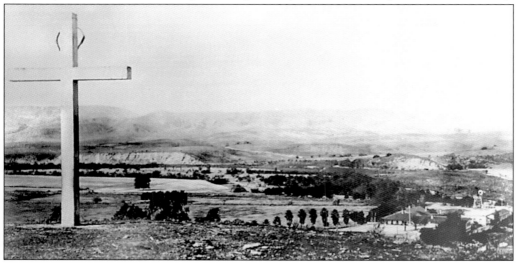

NORTHEAST VIEW OF RANCH AND WOOD MILL. In the early 1900s, when the family would entertain company, there was often a Victorian aura in the house. Certain topics (such as particular business dealings) were never discussed, and the demeanor of family members and guests was often very formal. (Courtesy of the MCB Camp Pendleton Archives.)

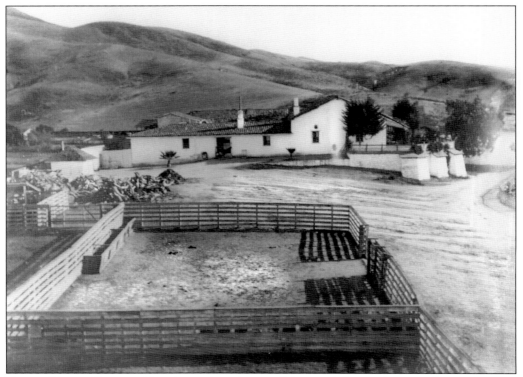

RANCH HOUSE CORRAL. Here is another picture of the ranch house during a thriving time in the early part of the 20th century. The O'Neill children would usually play near the ranch house, as there were not many other locations on the ranch. The young O'Neill boys would pretend that they were apprentices to the ranch carpenter and play with large pieces of lumber near the corrals. (Courtesy of the MCB Camp Pendleton Archives.)

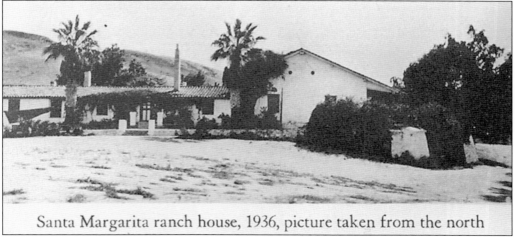

Santa Margarita ranch house, 1936, picture taken from the north

NORTHERN VIEW OF THE RANCH HOUSE, 1936. This is a view of the structure six years before the land would be come of part of the marine base. The house is a historic landmark on present-day Camp Pendleton. The Spanish-style home was the family residence and ranch headquarters. (Courtesy of the MCB Camp Pendleton Archives.)

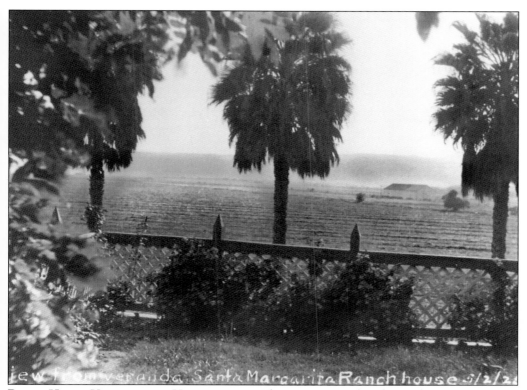

RANCH HOUSE, VIEW FROM THE VERANDA, 1925. This picture was taken during the Santa Margarita Company days. Duck hunters enjoyed winters on the ranch, as the birds would often arrive near the banks of the Santa Margarita River. Mail would be delivered to the ranch by train. The site received an abundance of business mail, and the vaqueros often received many letters from their families in Mexico. (Both courtesy of MCB Camp Pendleton Archives.)

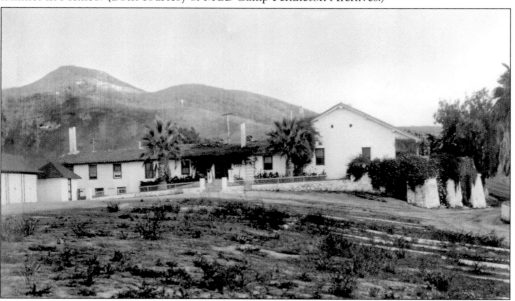

MULTIPLE PHASES. The historical buildings on the ranch were constructed over different periods in time. The contemporary version of the ranch house, of course, is much larger than the original version built in the 19th century. In the 1970s, the Boy Scouts of America established a camp at the Las Flores Estancia. (Both courtesy of MCB Camp Pendleton Archives.)

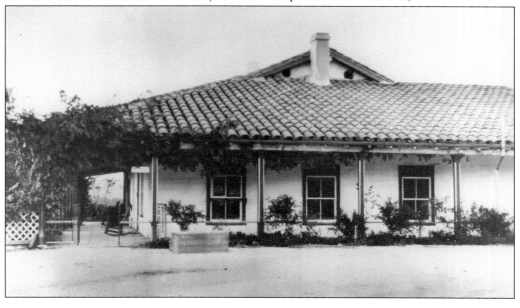

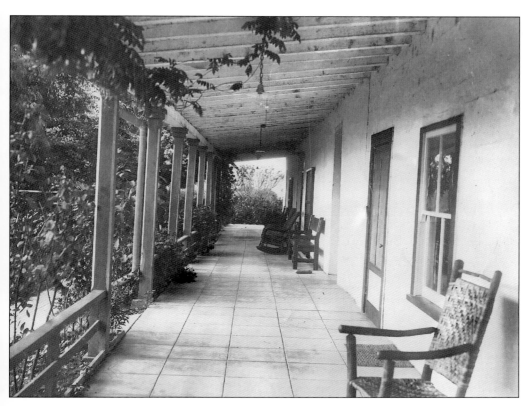

RANCH HOUSE VERANDA AND OFFICE, 1925. The house was well insulated; the combination of the adobe and tile roof ensured that the house was kept warm during the winter (the heat from the fireplace was kept within the structure) and cool during the summer months. (Both courtesy of MCB Camp Pendleton Archives.)

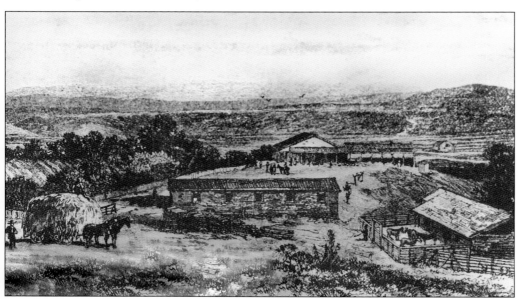

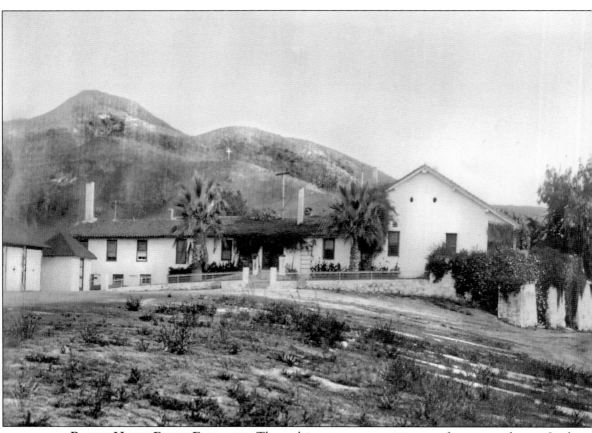

RANCH HOUSE FRONT ENTRANCE. The architecture was reminiscent of a noteworthy era. In the 1880s, Scotchman John Clay visited the ranch and wrote of the visit in *My Life on the Range*. In his book, he mistakenly stated that one could see the ocean from the front steps of the ranch house. This was impossible. (Courtesy of the MCB Camp Pendleton Archives.)

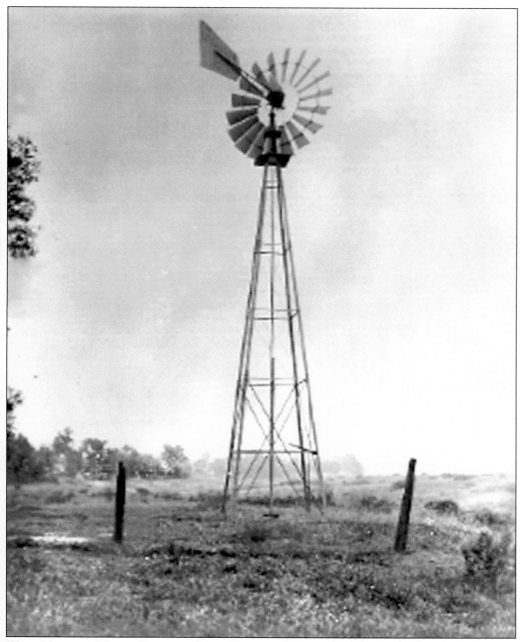

WIND MILL AND WATER CISTERN, 1900s. Here is a photograph of the windmill and water cistern during the early part of the 1900s. A major shift was occurring around this time. In 1911, the first automobile entered the ranch. From that point forward, machinery replaced horses as the ranch adapted for the 20th century. (Courtesy of the MCB Camp Pendleton Archives.)

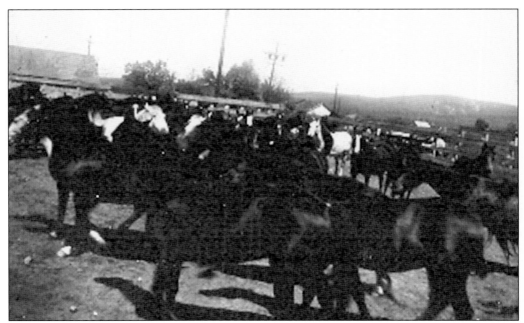

CORRALLED HORSES, 1935. The ranch was rich with cattle and horses. Each summer, the vaqueros rode their horses throughout the vast land to set up camps at San Onofre, San Mateo, Las Pulgas, and Mission Viejo. (Courtesy of the MCB Camp Pendleton Archives.)

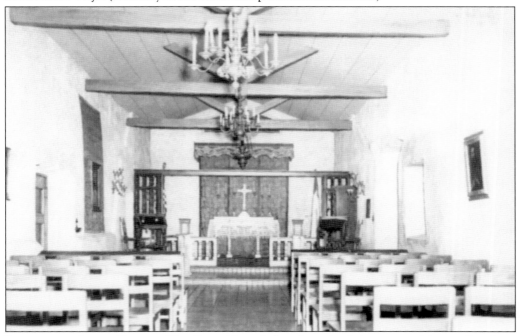

INTERIOR OF SERRA CHAPEL. The Serra Chapel, found north of this area at Mission San Juan Capistrano, is the oldest building in continuous use in California. The mission heritage of the Golden State is omnipresent in the region. Note the simplicity of the chapel (versus today) in this vintage photograph. (Courtesy of the MCB Camp Pendleton Archives.)

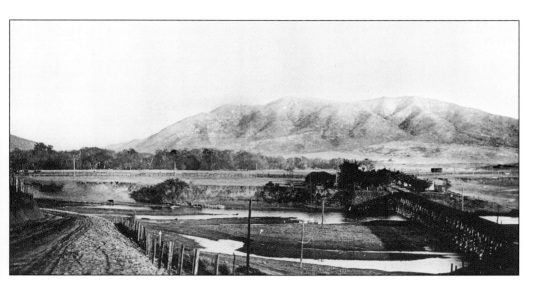

RANCH HOUSE. This picture includes the Santa Margarita River and railroad trestle. The house was not as isolated as other ranch houses in the West because a train ran in close proximity to the structure. (Both courtesy of the MCB Camp Pendleton Archives.)

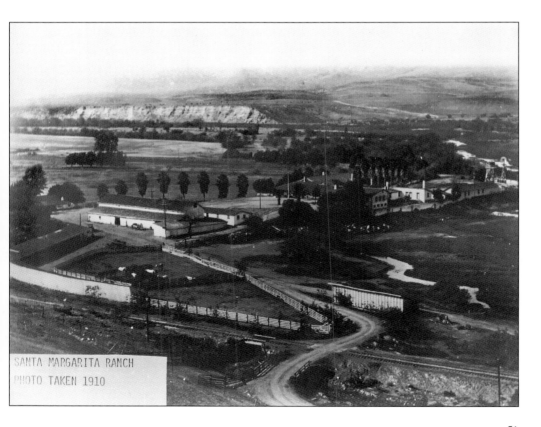

SANTA MARGARITA RANCH
PHOTO TAKEN 1910

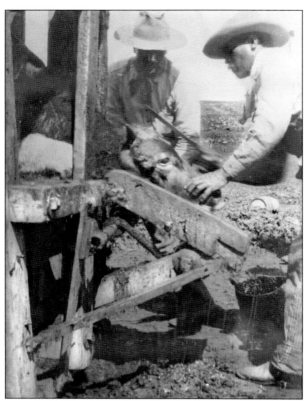

SLAUGHTERHOUSE PROCESS. A cow is being slaughtered in this photograph. The land was massive, and ranch hands kept busy with various types of activities. The ranch made a significant profit from the high-quality beef it produced. (Courtesy of San Juan Capistrano Historical Society.)

BARN. This barn on the ranch was a general storage facility used to house equipment and livestock. Upper floors often contained hay; trap doors released the hay into mangers where animals were located. Based on the popularity of tractors, some barns were replaced with Quonset huts after World War II. (Courtesy of Rancho Mission Viejo.)

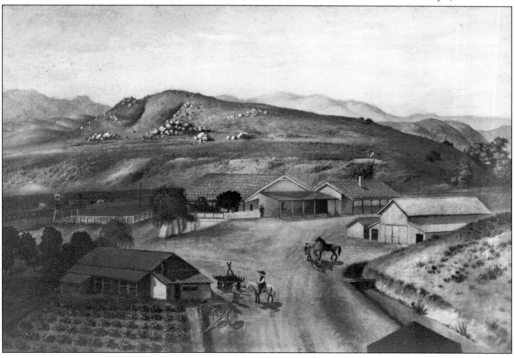

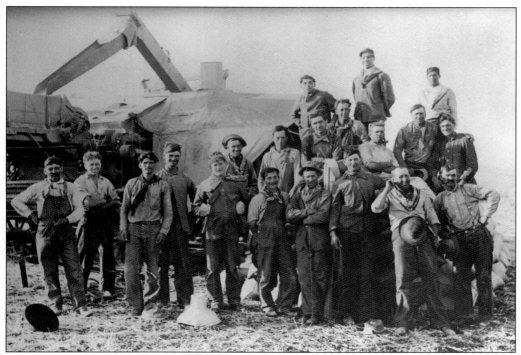

WORKERS ON THE RANCH. The ranch hands are putting in a hard day's work of various activities, including harvesting in the field and rounding up horses. Two distinct practices on the ranch were rodeo and branding. The rodeo referred to the rounding up of cattle in preparing for a cattle buyer's visit. They were often held in large, flat areas, while brandings often occurred in the corrals. (Both courtesy of San Juan Capistrano Historical Society.)

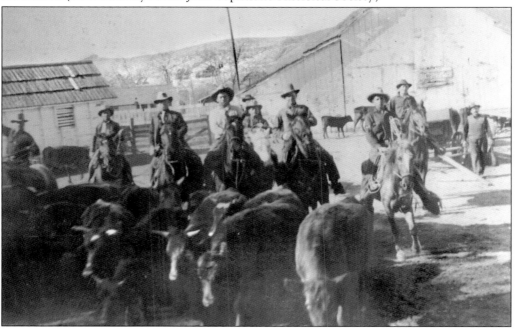

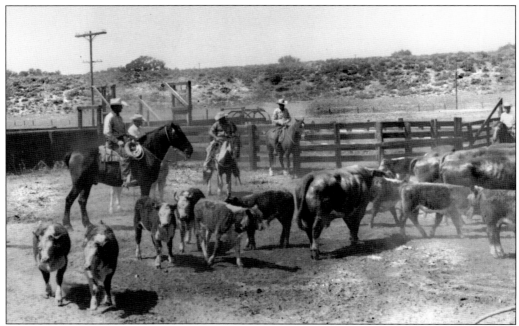

A Hotbed of Activity. Before rodeos were known as sporting events, they were the working practices of cattle herding, as depicted here. The writings describing the size of the land varies between 200,000 and 270,000 acres, as the ownership of different parcels would affect the total size. Roughly, the ranch was composed of 355 square miles, or an area about one-fourth the size of Rhode Island. (Both courtesy of San Juan Capistrano Historical Society.)

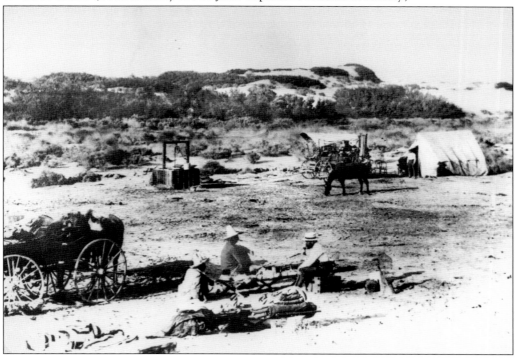

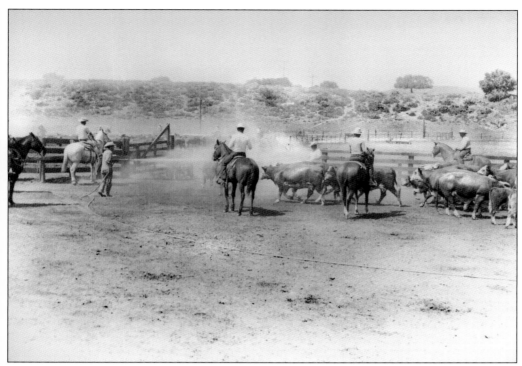

MORE RANCH ACTIVITY. Workers would often live with their families on the ranch. They ate, socialized, and slept on the grounds during the evening after putting in a hard day's work. The vaqueros did not have much time for leisure activities—their duties often required them to work from sunrise to sunset. As there was really nowhere for them to go when they did have free time, they often played poker in the evenings. (Both courtesy of San Juan Capistrano Historical Society.)

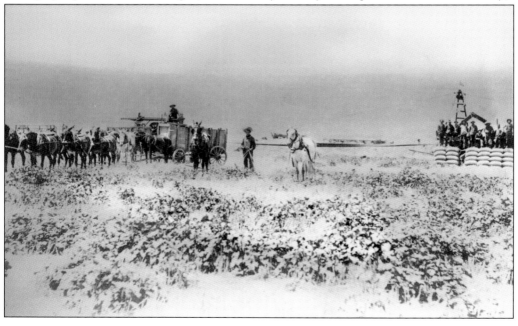

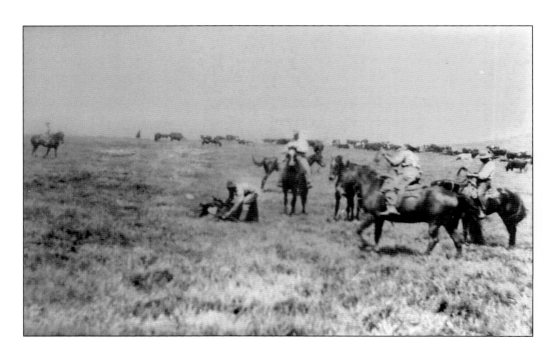

BRANDING AND HARVESTING. In 1913, California passed a law that stated that all brands must be registered. Until that time, ranchers could adopt any brand of their choice. Thus, the "TO" brand was adopted when cattle from Texas was purchased for use in the 1880s. (Both courtesy of San Juan Capistrano Historical Society.)

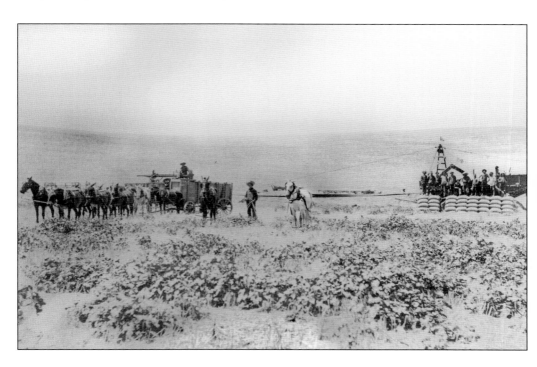

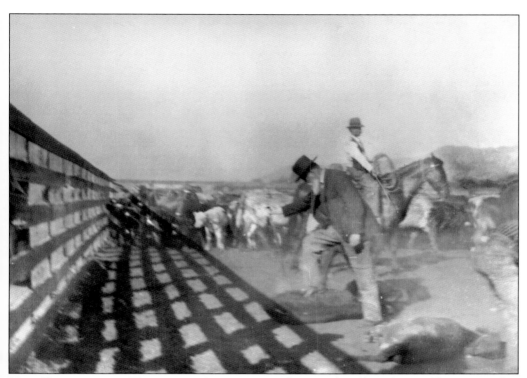

MORE BRANDING AND HARVESTING. Here are more photographs of branding and harvesting that occurred. Bull calves would undergo a process of castration, dehorning, earmarking, and any necessary medical steps. (Both courtesy of San Juan Capistrano Historical Society.)

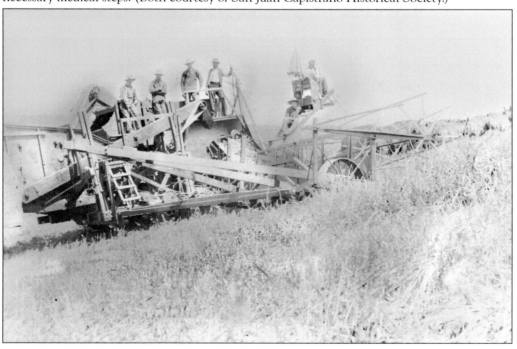

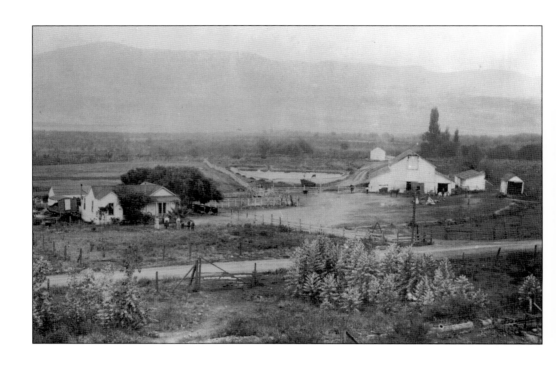

A Simpler Time. Here are pictures of the ranch, along with a buggy used for transportation. The first automobile did not enter Rancho Santa Margarita until 1911. That marked the start of a shift from traditional harvesting methods to new technologies and machinery. (Both courtesy of San Juan Capistrano Historical Society.)

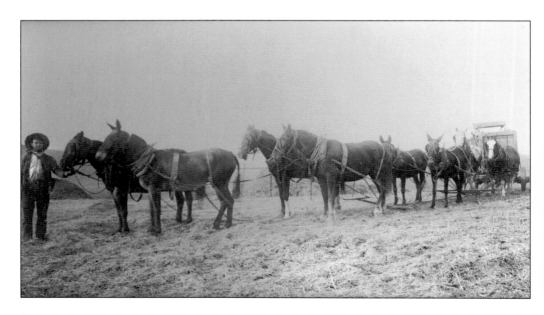

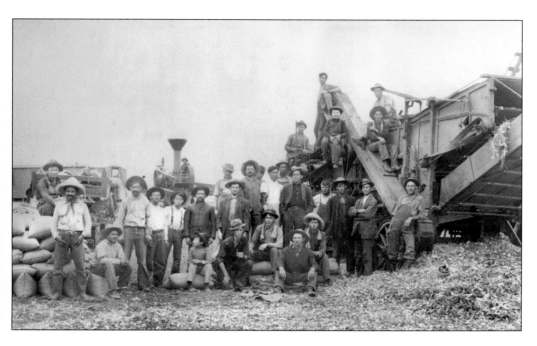

HARVESTING AND RODEO ACTIVITIES GALORE. Many workers on the ranch were longtime employees with intriguing stories. For example, the ranch cook, Sing Yung, was an immigrant from China. (Both courtesy of San Juan Capistrano Historical Society.)

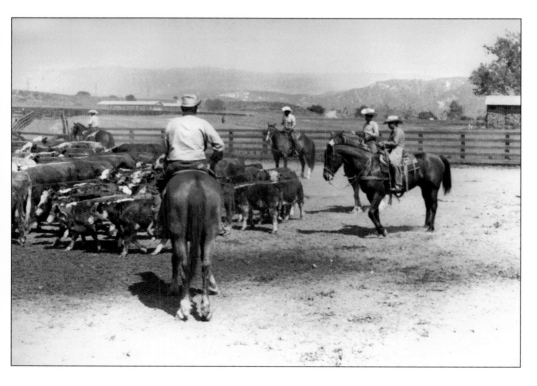

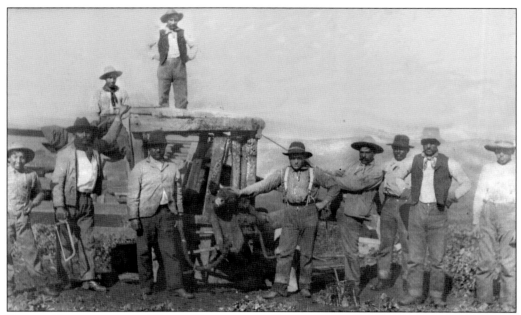

CATTLE OPERATION AND WHEAT HARVESTING. Two practices that the ranch was known for were cattle operations and wheat harvesting. The cattle operation included the responsibility of a clean meat product, ultimately by supplying finished beef. While Central California is known as the agricultural hotbed of the Golden West today, at one time, Rancho Santa Margarita boasted a significant sized wheat field in the state. (Both courtesy of San Juan Capistrano Historical Society.)

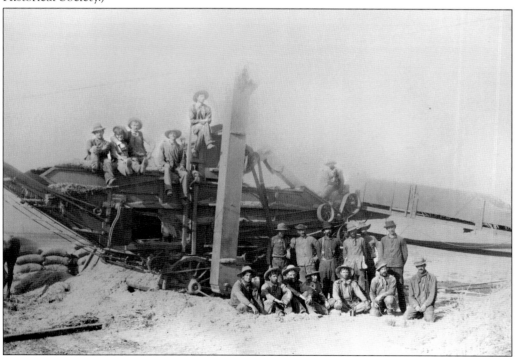

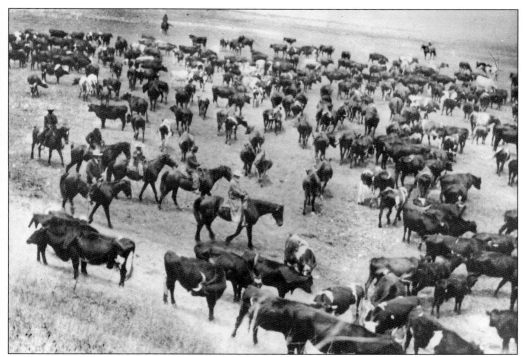

AN ABUNDANT RANCH. The ranch abounded with cattle and other forms of livestock from the time that the ranches were used by the Spanish missionaries, through the Mexican period, and on through the ownership of the O'Neill family—before its development. The pleasant California weather enabled a thriving environment for agriculture and livestock. The same weather draws families from around the country to move to the city today. (Both courtesy of Rancho Mission Viejo.)

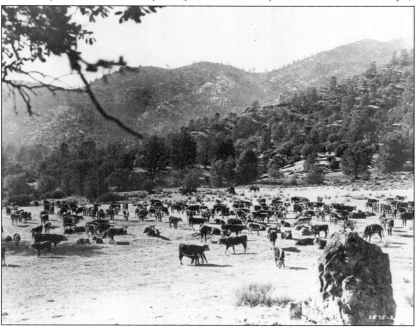

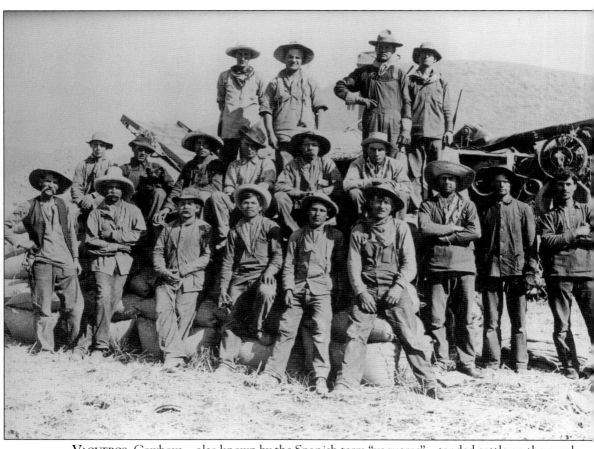

VAQUEROS. Cowboys—also known by the Spanish term "vaqueros"—tended cattle on the ranch. Their work served as the cornerstone of ranch activity. The men would usually live in one large room of a bunkhouse. The majordomo and artisans who worked on the ranch would often have their own rooms, as would harness-makers, blacksmiths, and carpenters. Riding gear was stored in a separate room of the bunkhouse. (Courtesy of San Juan Capistrano Historical Society.)

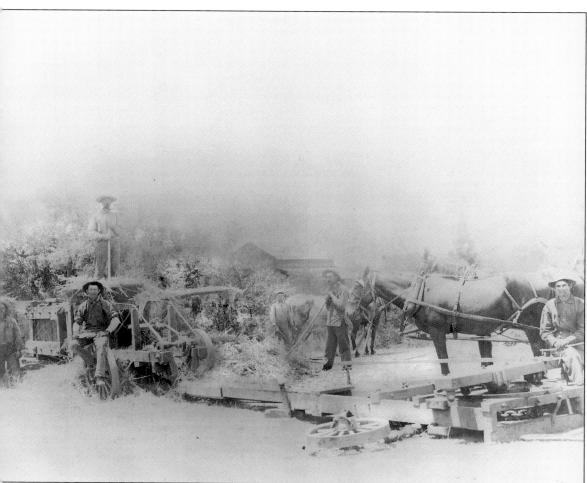

WHEAT HARVESTING. Rancho Trabuco contained one of the greatest wheat fields in Orange County. During the harvest season, the ranch threshing machine employed the use of from 32 to 42 horses and drew power from gears that were a part of the primary axle. (Courtesy of MCB Camp Pendleton Archives.)

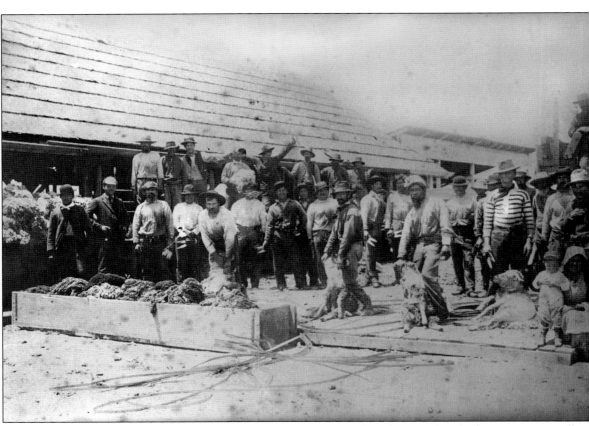

SHEEP SHEARING, 1887. The ranch had a plentiful stock of sheep on hand. Sheep were normally shorn once a year. During the 1870s, the mesa contained nearly 20,000 sheep, which were leased by Miguel Erreca. Two flocks of 2,500 were driven to San Francisco for sale every two years. (Courtesy of San Juan Capistrano Historical Society.)

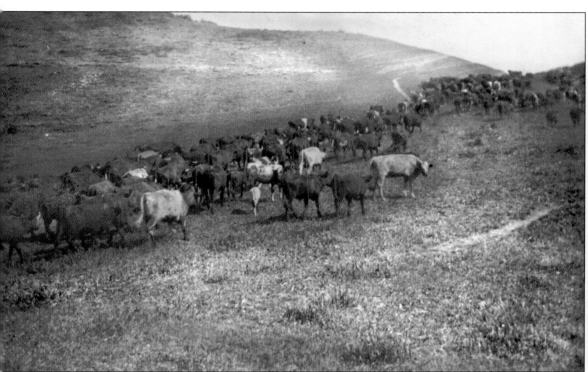

THE CATTLE RANCH, 1900. Cattle ranching was a significant part of ranch business during the 19th and 20th centuries. Three O'Neill family brands have been the TO, Bell, and Rafter M brands. The mesa served as a pasture for horses, sheep, and cattle. Richard O'Neill Sr. imported stock from Texas to upgrade the longhorns that were native to the area. The shorthorn beef that he marketed was known as the Flood and O'Neill brand. The cattle grazed from present-day Oceanside to present-day Aliso Creek. (Courtesy of San Juan Capistrano Historical Society.)

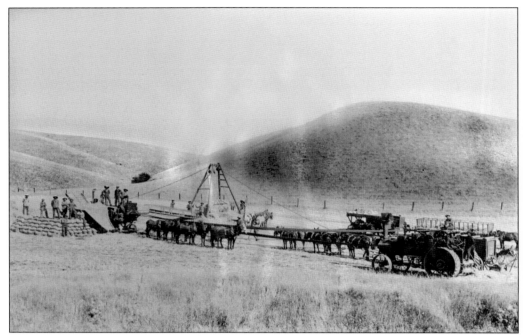

THRESHING MACHINE, 1903. This threshing machine was used to separate grain from stalks and husks. In the early 1900s, the mesa was the greatest wheat field in Orange County. (Courtesy of San Juan Capistrano Historical Society.)

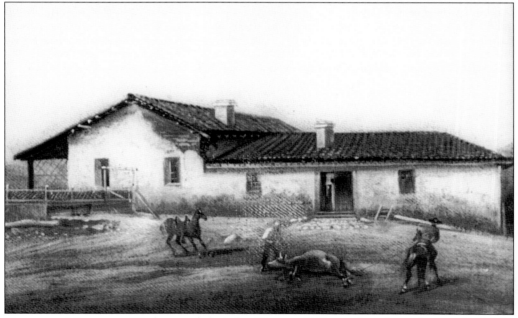

HACIENDA MANTAZA. Workers and their families would live and work on the ranch. Adobe structures were very common in the 1800s. Some are still present today in San Juan Capistrano and Camp Pendleton, and the remains of others exist in areas such as present-day Rancho Santa Margarita. (Courtesy of San Juan Capistrano Historical Society.)

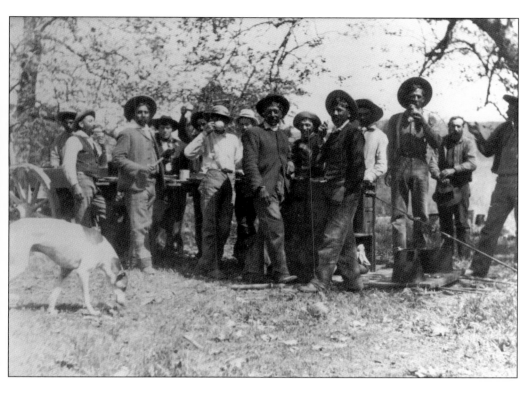

WORKERS ON THE RANCH. Those who worked on the ranch tended to various types of livestock and wheat harvesting. Workers conducted activities such as sheering, cattle branding, and various other ranch tasks. Ranch workers were often composed of entire families. (Both courtesy of San Juan Capistrano Historical Society.)

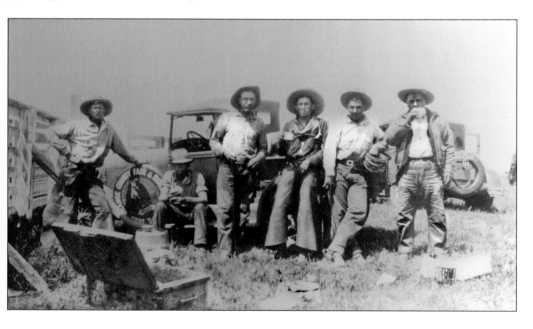

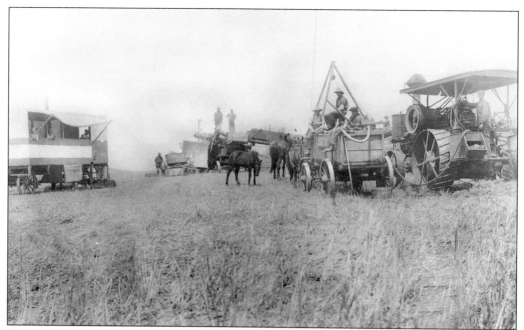

FARMING, 1915. Here is another photograph of a wheat harvest. Around this time, the implementation of new technology was occurring at ranches throughout the country. (Courtesy of the MCB Camp Pendleton Archives.)

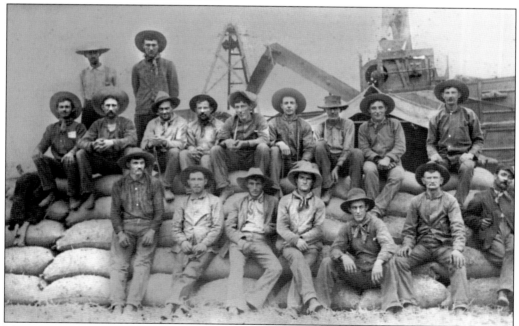

MORE WORKERS. Here are more workers after a long day of work. The California heat could make working the summer months especially difficult. Ranch workers often helped with wheat harvesting, cattle roundups, and general maintenance activities. (Courtesy of San Juan Capistrano Historical Society.)

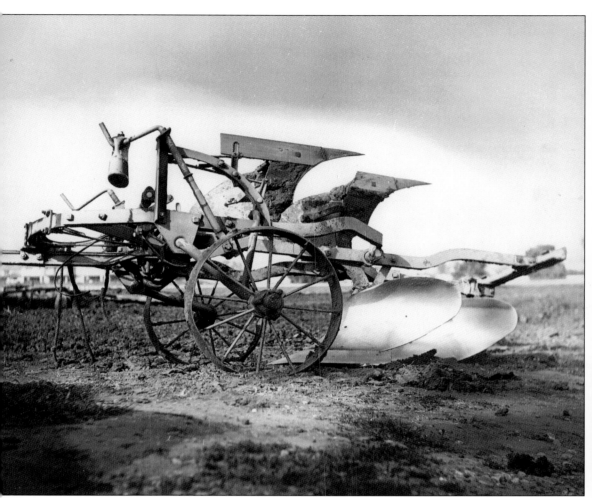

PLOW. This horse-drawn, two-furrow plow from the ranch is typical of one of the most important tools that farmers used to work the land. (Courtesy of San Juan Capistrano Historical Society.)

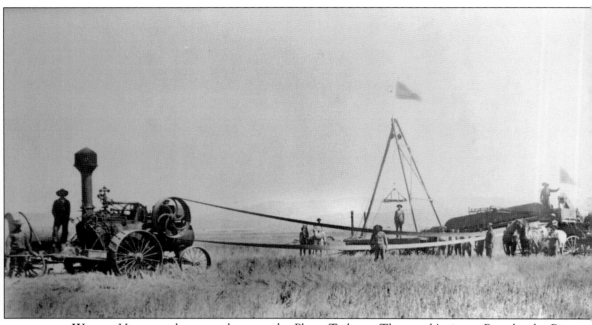

WHEAT. Here men harvest wheat on the Plano Trabuco. The ranch's ties to Portola, the Picos, wheat harvests, livestock raising, the military, and housing developments make Rancho Santa Margarita one of the most noteworthy pieces of real estate in California. (Courtesy of San Juan Capistrano Historical Society.)

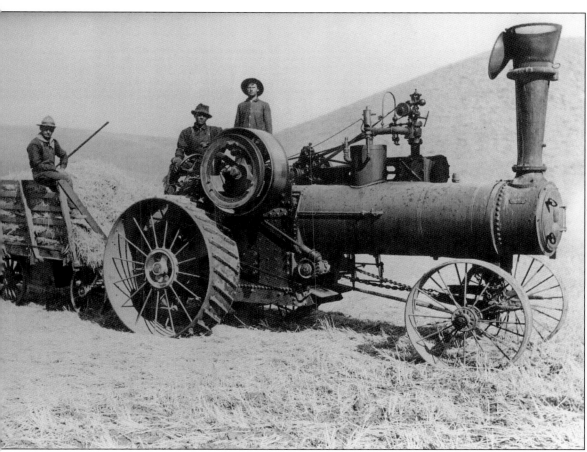

TRACTOR. Here a steam-driven tractor is used to gather wheat. The early part of the 20th century marked the advent of new technologies. Such machinery made tasks such as wheat harvesting much more efficient and profitable. (Courtesy of San Juan Capistrano Historical Society.)

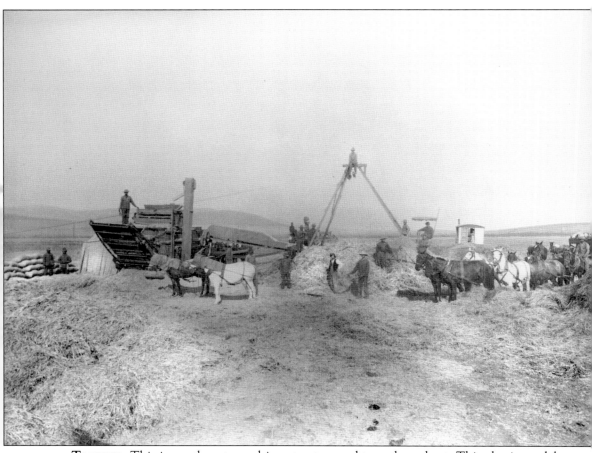

TRACTOR. This is another steam-driven tractor used to gather wheat. This classic model was innovative for its time. (Courtesy of San Juan Capistrano Historical Society.)

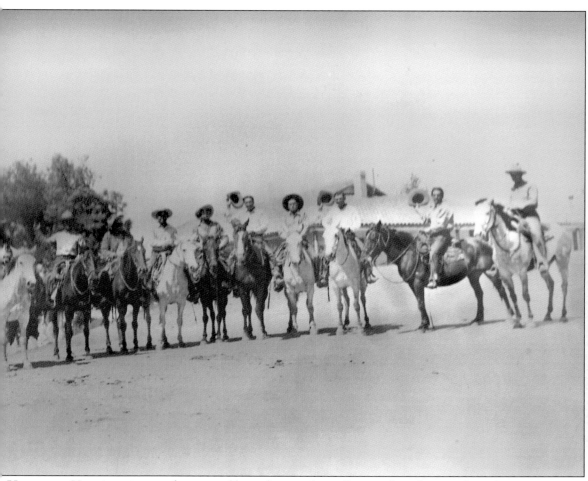

VAQUEROS. Here is a picture of a team of legendary cowboys. During their day, ranch workers smoked cigarettes that they rolled by hand. The vaqueros at Rancho Santa Margarita preferred to smoke Bull Durhams. On some evenings, visitors to the ranch could hear the vaqueros playing their guitars and singing in their bunkhouse. (Courtesy of Rancho Mission Viejo.)

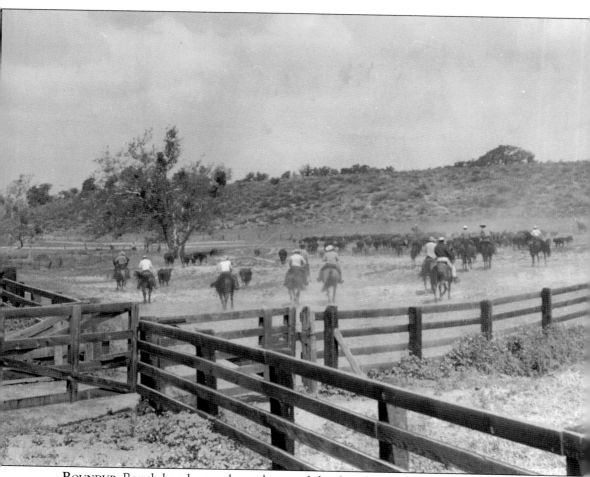

ROUNDUP. Ranch hands stayed very busy and developed an expertise in the process of raising healthy animals, as depicted in this photograph. Numerous herds of animals of the ranch included cows, sheep, horses, and mules. (Courtesy of San Juan Capistrano Historical Society.)

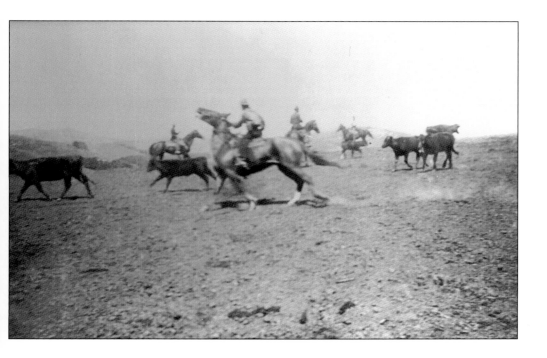

ROUNDUP. The roundup was common throughout ranches and farms in the United States, and Rancho Santa Margarita had a dedicated staff of expert cattlemen to perform the necessary duties. (Both courtesy of San Juan Capistrano Historical Society.)

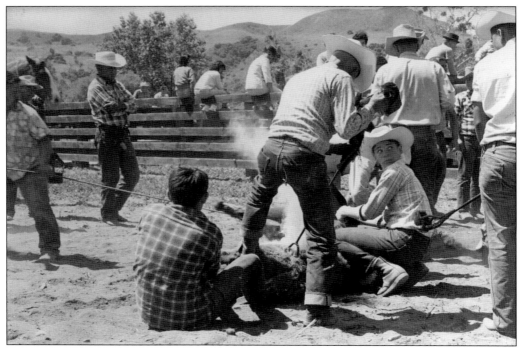

BRANDING. There were numerous brands from the mission era to the present day. The Rafter M brand (see page 89) has been known as not only a cattle brand, but also a symbol of the area and the influence of the O'Neill family. (Both courtesy of San Juan Capistrano Historical Society.)

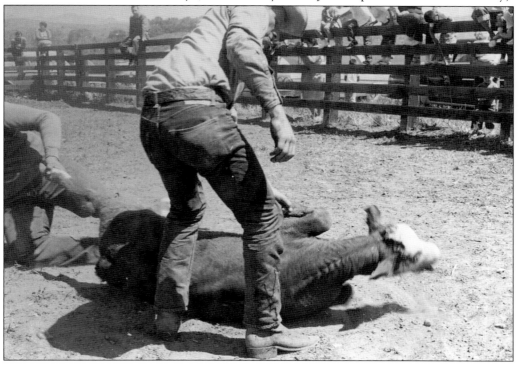

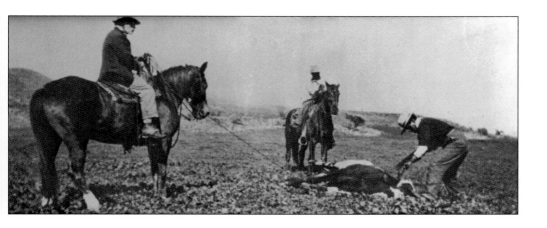

BRANDING. Branding requires skill and practice. Ancient Egyptians were the first to use heated marks to signify their ownership of livestock. The practice became common throughout the American West. Today branding includes new techniques such as freeze branding. (Both courtesy of San Juan Capistrano Historical Society.)

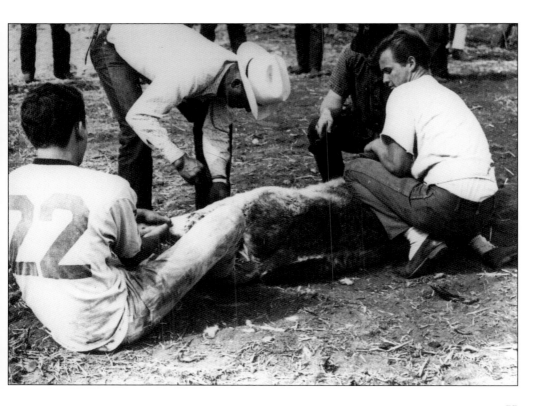

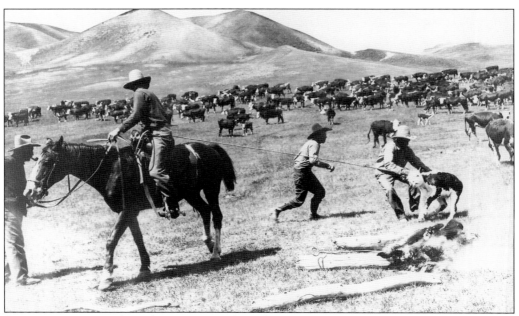

BRANDING. Here ranch workers are going about the routine that they have become proficient at. (Both courtesy of San Juan Capistrano Historical Society.)

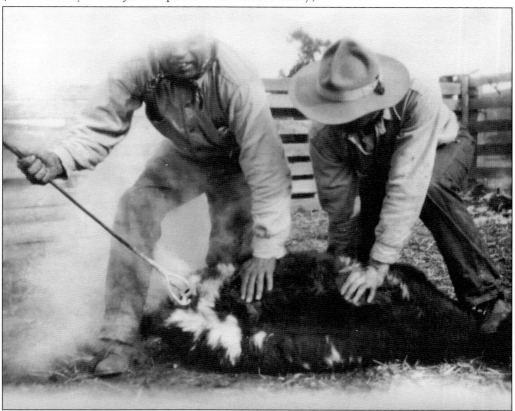

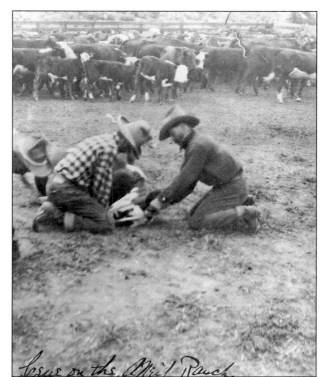

Issue on the O'Neil Ranch.

BRANDING. Most brands in the United States are composed of capital letters, numbers, or symbols. Such is the case with the various brands used on the ranch over the years. (Both courtesy of San Juan Capistrano Historical Society.)

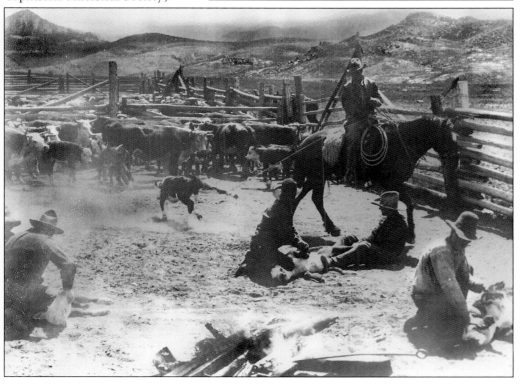

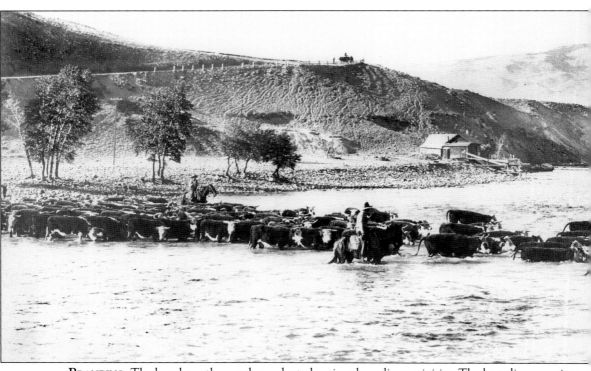

BRANDING. The hands on the ranch conducted various branding activities. The branding exercises were the traditional means of roping the livestock, tying the legs together, and applying the branding iron to the animals. (Courtesy of San Juan Capistrano Historical Society.)

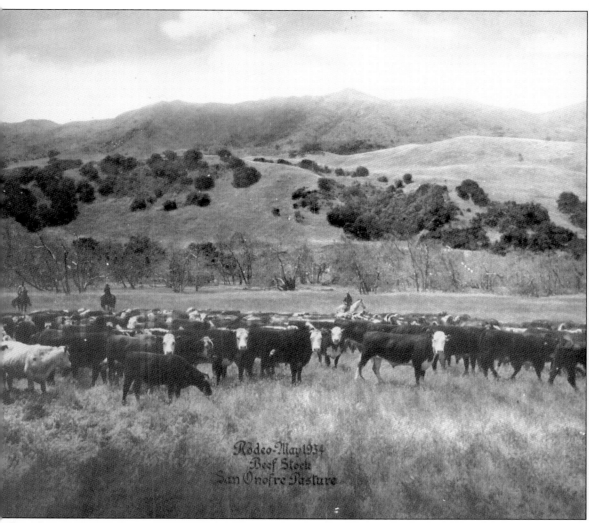

Rodeo-May 1934
Beef Stock
San Onofre Pasture

BEEF STOCK IN PASTURE, 1934. Here is a photograph of beef stock in the pasture. This was likely near the San Onofre area. As stated throughout this book, the ranch was rich with various types of livestock. The cattle brand of this era was the Flood-O'Neill brand. (Courtesy of the MCB Camp Pendleton Archives.)

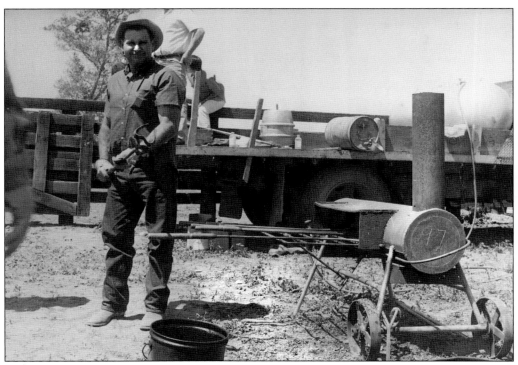

BRANDING APPARATUS. The mechanism used to brand ranch animals was composed of a propane forge that was used to heat the branding iron and keep the irons ready to brand. Branding, of course, was one of the most common activities on the ranch. (Both courtesy of Rancho Mission Viejo.)

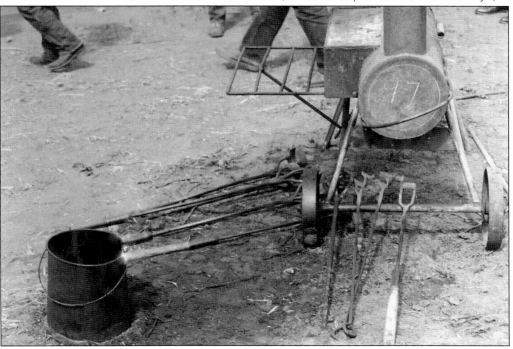

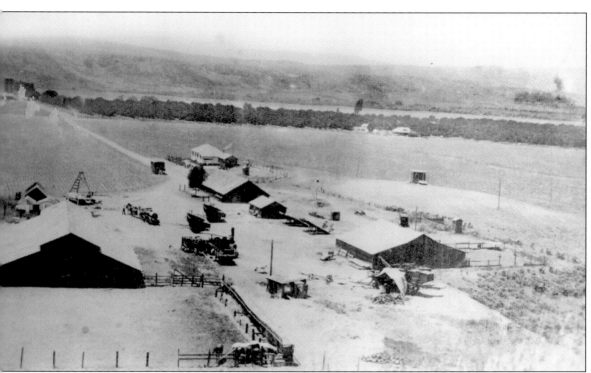

An Early View. Here is another early view of Rancho Santa Margarita y Las Flores. One of the most fascinating aspects of the story of Rancho Santa Margarita y Los Flores was the ranch's ownership by diverse individuals; thus, the stories of the ranch are diverse, from a Spanish expedition to the Mexican era, Forster's involvement, Flood's investment, O'Neill's leadership, and the transforming of the land into a U.S. Marine base. (Courtesy of Rancho Mission Viejo.)

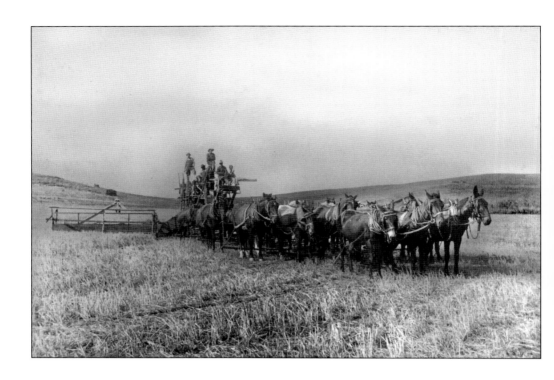

MESA WHEAT HARVEST, 1896. Here 36 head are pulling Orange County's initial combine. The land served as a prosperous area for the harvesting of wheat. The spread resulted in a yield of 21,000 sacks of grain. The cultivation occurred over 3,500 acres and peaked during World War I. The first planting occurred in 1893; by 1913, Plano Trabuco was one of the greatest wheat fields in Orange County. (Both courtesy of San Juan Capistrano Historical Society.)

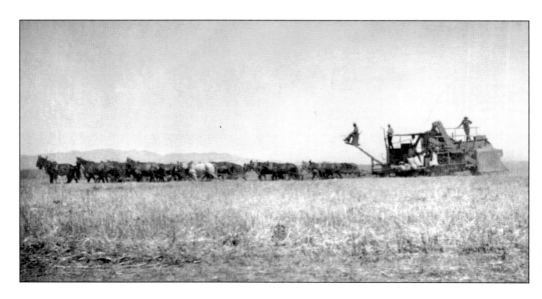

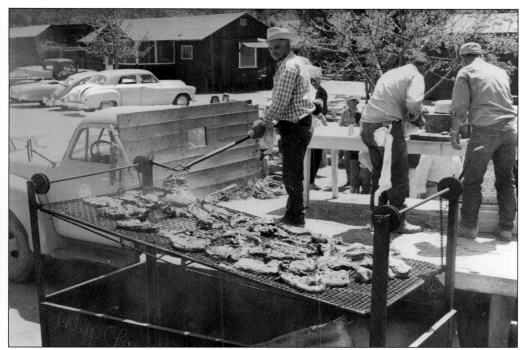

BARBEQUE TIMES AT THE RANCH. Ranchers often celebrated with barbeques and other types of social activities. Days were long, and the prosperous ranch kept workers busy. (Courtesy of San Juan Capistrano Historical Society.)

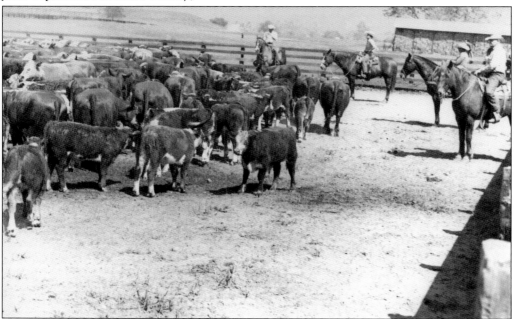

CATTLE ON THE MESA. Numerous brand of cattle appeared in the ranches, including thousands of free-roaming cattle and horses. Despite this, relatively few people lived on the Rancho Santa Margarita y Las Flores. (Courtesy of San Juan Capistrano Historical Society.)

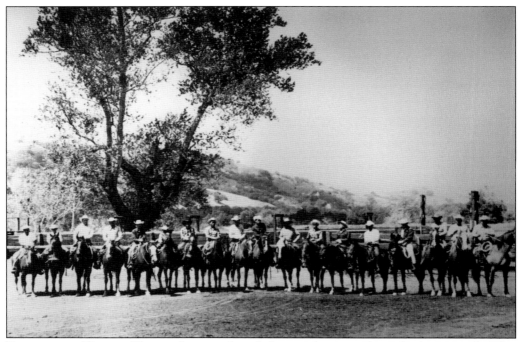

POSING WITH HORSES. The ranch was rich with horses, sheep, cattle, and other animals. This group is possibly going to embark on a horseback expedition through the area's rolling hills. Though many parts of the ranch are a master-planned community today, the surrounding hills and trails offer a hint of the serene way of life during a much simpler time. (Courtesy of San Juan Capistrano Historical Society.)

Southwest corner of Santa Margarita ranch house, 1936. John Forster of San Juan Capistrano stands beside huge tallow kettle brought around the Horn by his grandfather, Don Juan Forster

THE CORNER OF THE RANCH HOUSE, 1936. Here John Forster stands beside the huge tallow kettle placed here by his grandfather, Don Juan Forster. His father had started Forster City, a short-lived settlement (1878–1882) located at present-day San Onofre. (Courtesy of the MCB Camp Pendleton Archives.)

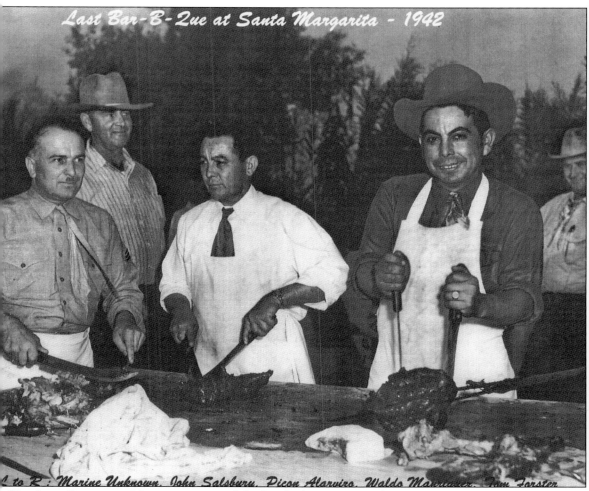

Last Bar-B-Que at Santa Margarita - 1942

L to R : Marine Unknown, John Salsbury, Pico Alanviza, Waldo Mar...... Forster.

THE LAST BARBEQUE. Here is a picture of the last barbeque at Rancho Santa Margarita y Las Flores before the land became the Camp Pendleton Marine Corps Base. When it opened, Camp Pendleton was the largest military base in the world. (Courtesy of Rancho Mission Viejo.)

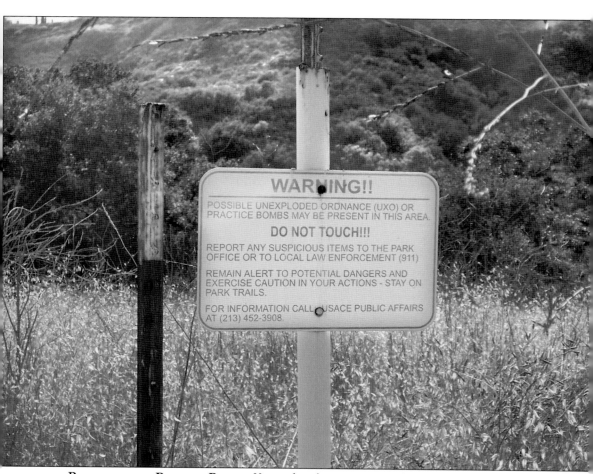

WARNING!!

POSSIBLE UNEXPLODED ORDNANCE (UXO) OR
PRACTICE BOMBS MAY BE PRESENT IN THIS AREA.

DO NOT TOUCH!!!

REPORT ANY SUSPICIOUS ITEMS TO THE PARK
OFFICE OR TO LOCAL LAW ENFORCEMENT (911)

REMAIN ALERT TO POTENTIAL DANGERS AND
EXERCISE CAUTION IN YOUR ACTIONS - STAY ON
PARK TRAILS.

FOR INFORMATION CALL USACE PUBLIC AFFAIRS
AT (213) 452-3908

REMNANTS OF A BOMBING RANGE. Years after the area was used as a bombing range, the message is clear: "Possible Unexploded Ordinance or Practice Bombs May be Present in this Area." The Trabuco Bombing Range was also known as the "Plano Trabuco Target Area" or "Temecula Bombing Range" from 1944 to 1956. Today the area is part of the Arroyo Trabuco Wilderness trail, located in the same mesa where the Portola expedition once camped.

Three

THE O'NEILL FAMILY LEGACY

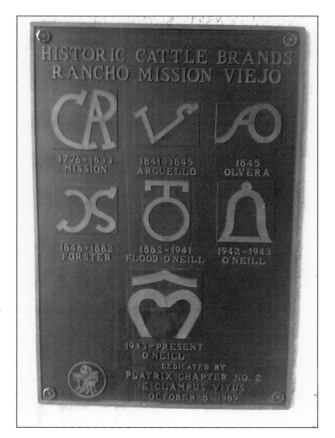

THE CATTLE BRANDS. This plaque, located at the entrance of Rancho Mission Viejo headquarters, displays the historic cattle brands associated with the ranches. The brands included the Mission (1776–1833), Arguello (1841–1845), Olvera (1845), Forster (1846–1882), Flood-O'Neill (1882–1941), O'Neill (1942–1943), and O'Neill (1943–present). The current "Rafter M" brand is the signature emblem that is located on the seals of the cities of both Rancho Santa Margarita and Mission Viejo. The rafter represents a roof, which is indicative of warmth and friendliness.

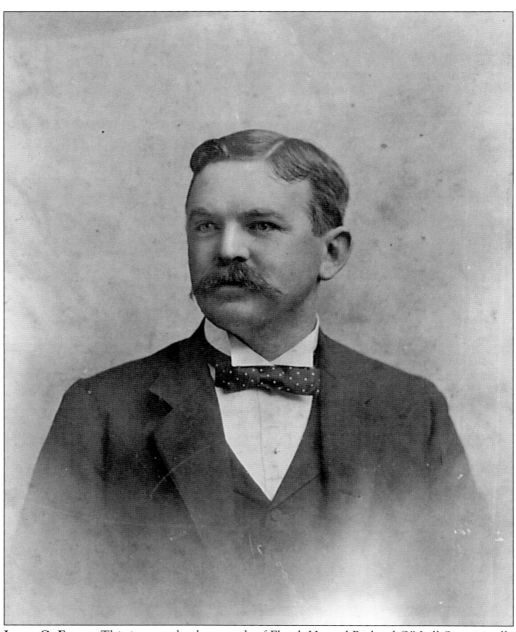

JAMES C. FLOOD. This is an early photograph of Flood. He and Richard O'Neill Sr. originally lived on the East Coast, but traveled west in the pursuit of riches during California's Gold Rush. While they did not discover gold, Flood achieved business success through numerous endeavors, including involvement with Wells Fargo Bank, the ownership of a saloon, and profiting from the Comstock Lode, the first great silver mining district in the United States. As the investor of capital in the Rancho Santa Margarita y Las Flores partnership, Flood remained in San Francisco while O'Neill managed the ranch. Flood would occasionally travel south to visit the ranch, often for recreation. Their ranch partnership was based on nothing more than a handshake. (Courtesy of MCB Camp Pendleton Archives.)

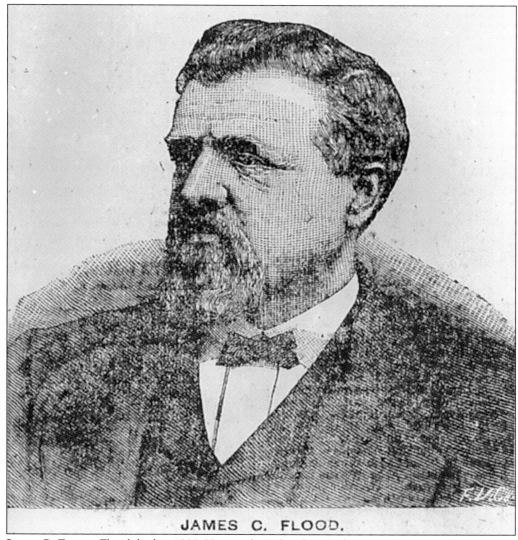

JAMES C. FLOOD.

James C. Flood. Flood died in 1889. He was the "silver king" who earned a tremendous amount of money through numerous business dealings. His mansion on Nob Hill in San Francisco was one of only two structures to not collapse or burn to the ground during the 1906 earthquake and fire. Today the mansion is home to the Pacific Union Club. (Courtesy of MCB Camp Pendleton Archives.)

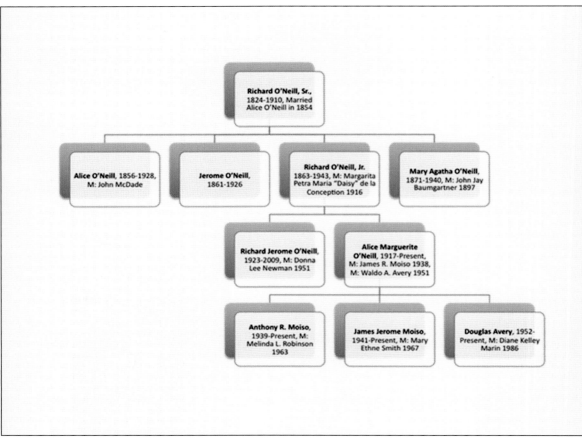

THE O'NEILL FAMILY TREE. This chart shows the relationship of the members of the O'Neill/Baumgartner/Moiso family and, specifically, the lineage from Richard O'Neill Sr. to current Rancho Mission Viejo CEO Anthony Moiso and the late Richard J. O'Neill. Moiso and his uncle oversaw the opening of the town of Rancho Santa Margarita and were instrumental figures in the shaping of modern-day south Orange County.

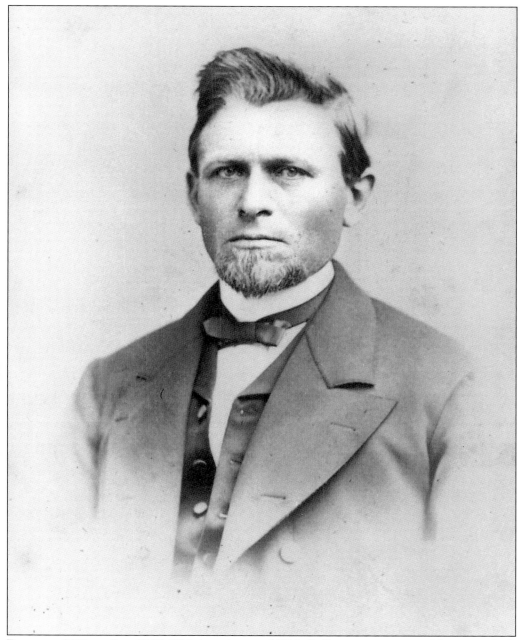

RICHARD O'NEILL SR., 1885. This is a picture of O'Neill. Sr. as a young man. He was an Irish immigrant and expert cattleman. Tony Forster, the grandson of Don Juan Forster, once described O'Neill Sr. by saying, "He was very slight of build and very short, but you almost stood at attention when he came around. He gave orders constantly and no one dared disobey him. He worked hard himself, getting up all hours of the night, and everyone on the ranch had to work. He wore boots and denim trousers most of the time because he actively worked the ranch. He generally had a short stubble of beard. He was a little man in stature, but big in personality." (Quote courtesy of San Juan Capistrano Historical Society, photograph courtesy of Rancho Mission Viejo.)

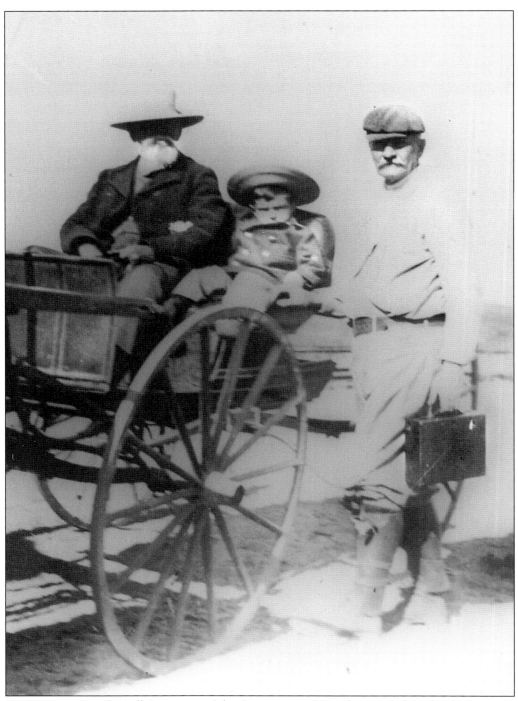

THE FAMILY. Here O'Neill Sr., a young John Baumgartner Jr., and a man believed to be James C. Flood pose in a buggy. They were pioneers of the development of a portion of Southern California. O'Neill, known for his Vandyke (a trim pointed beard), began the O'Neill family legacy on the land. (Courtesy of the MCB Camp Pendleton Archives.)

RICHARD O'NEILL SR. IN BUGGY, 1905. The picture depicts Richard O'Neill Sr. with a young John Baumgartner Jr. O'Neill's partner, James Flood, was one of the wealthiest individuals in America at the time of his death. (Courtesy of MCB Camp Pendleton Archives.)

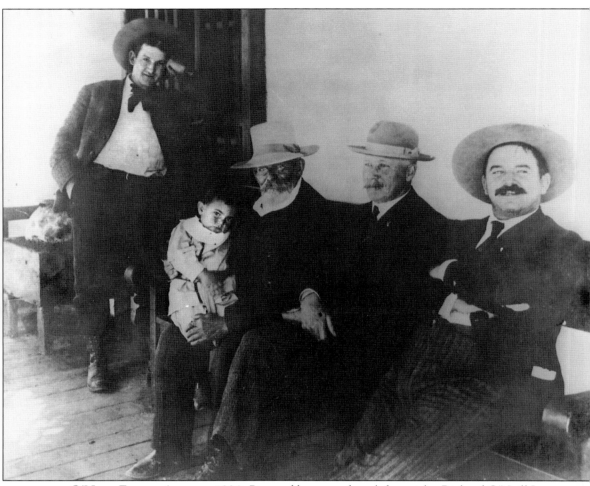

O'NEILL FAMILY, AROUND 1920. Pictured here are, from left to right, Richard O'Neill Jr., a very young John Baumgartner Jr., Richard O'Neill Sr., an unidentified man, and Jerome O'Neill. (Courtesy of the MCB Camp Pendleton Archives.)

RANCHO LAS FLORES IN THE 1890s. The picture shows life at Rancho Las Flores during the latter part of the 19th century, when Richard O'Neill Sr. oversaw ranch operations. (Courtesy of the MCB Camp Pendleton Archives.)

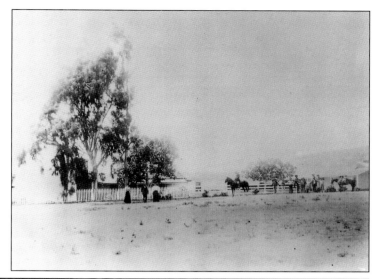

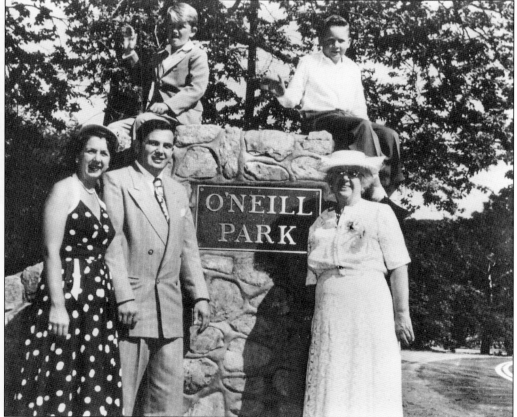

DEDICATION OF O'NEILL PARK, 1951. Pictured from left to right are Alice O'Neill Avery, Richard J. O'Neill, Jerome Moiso, Anthony Moiso, and Marguerite O'Neill. Alice is the mother of Jerome and Anthony. The O'Neills donated the land for public use. Today the park comprises 3,358 acres. (Courtesy of Rancho Mission Viejo.)

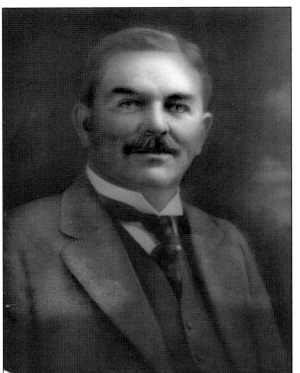

JEROME O'NEILL. The son of Richard O'Neill Sr. assumed leadership of the ranch after his father's health declined. The ranch flourished under the younger O'Neill's leadership despite such challenges as a major drought. Though he suffered from polio and had trouble walking, he was known as a good horseman who was serious, straightforward in his communications, and fully immersed in the managing of the ranch. (Courtesy of Rancho Mission Viejo.)

ALICE O'NEILL. Alice was the wife of Richard O'Neill Sr. and mother of Richard Jr. and Jerome. (Courtesy of Rancho Mission Viejo.)

JOHN BAUMGARTNER. The brother-in-law of Richard O'Neill Jr. and Jerome O'Neill, Baumgartner was part-owner of part of the San Diego portion of the ranch before it was transformed into Camp Pendleton. He was an excellent ranch cowboy. (Courtesy of Rancho Mission Viejo.)

JEROME O'NEILL WITH COMPANY. Here Jerome O'Neill (far left) enjoys the company of Viola van der Leck, Chonita van der Leck, and an unidentified woman. It is unknown as to why Jerome O'Neill assumed control of the ranch over his siblings, as business arrangements were often confidential in the Victorian Age. The most likely reason was that Jerome was the eldest son. (Courtesy of Rancho Mission Viejo.)

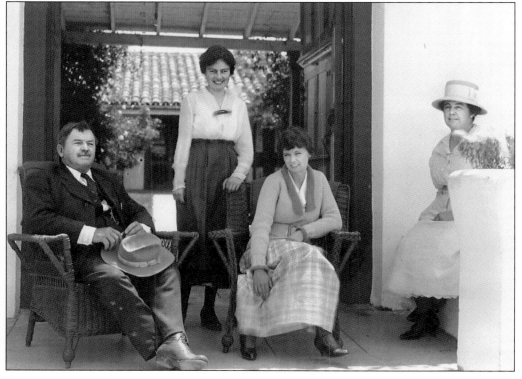

RICHARD O'NEILL JR. The son of Richard O'Neill Sr., Richard Jr. was the father of Alice O'Neill Avery and Richard J. O'Neill. He retained the Orange County parcels of the ranch when the Santa Margarita Company was dissolved in 1939. (Courtesy of Rancho Mission Viejo.)

DAISY O'NEILL. Daisy was the wife of Richard O'Neill Jr., the mother of Richard J. O'Neill and Alice O'Neill Avery, and the grandmother of Anthony Moiso. She and Richard O'Neill Jr. would possess the southern Orange County portion of the ranch after the U.S. government purchased the northern San Diego portion to build Camp Pendleton. (Courtesy of Rancho Mission Viejo.)

100

DAISY O'NEILL AND STAFF AND FAMILY PHOTOGRAPH. The picture at right depicts Daisy O'Neill. The picture below shows O'Neill family members and Mission Viejo Company staff members posing in 1968. Many of these individuals were instrumental in the development of the community of Rancho Santa Margarita. (Both courtesy of Rancho Mission Viejo.)

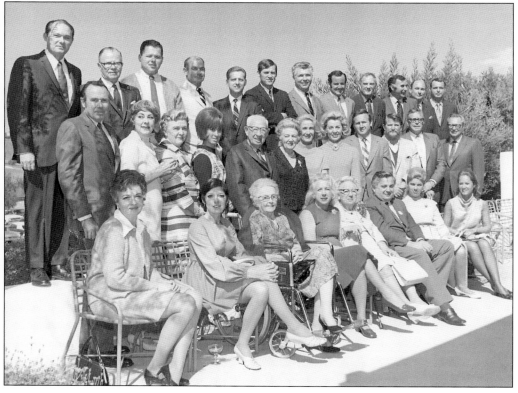

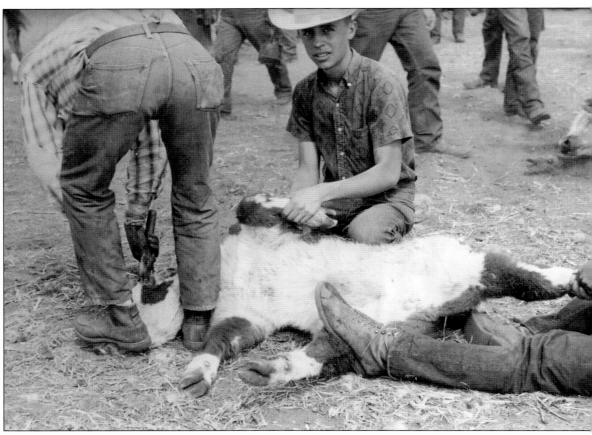

EARLY PHOTOGRAPH OF RICHARD J. O'NEILL. This is a photograph of Richard J. O'Neill branding cattle while in his mid-teens. O'Neill attended Beverly Hills High School, but often spent summers on the ranch. (Courtesy of San Juan Capistrano Historical Society.)

RICHARD J. O'NEILL. The grandson of Richard O'Neill Sr., O'Neill and nephew Anthony Moiso played an enormous role in the development of south Orange County, including Rancho Santa Margarita. When he passed away in 2009, the *Los Angeles Times* eulogized: "He served as the California Democratic Party chairman from 1979 to 1981 and helped transform the landscape of Orange County by developing his family's vast Rancho Mission Viejo." (Courtesy of Rancho Mission Viejo.)

ALICE O'NEILL AVERY. This is an picture of Alice O'Neill Avery, the sister of Richard J. O'Neill and the mother of Anthony Moiso. In 1963, she and Richard J. O'Neill decided to sell 11,000 acres of the ranch for non-agricultural development. The land would become the City of Mission Viejo. (Both courtesy of Rancho Mission Viejo.)

ANTHONY MOISO. Today Anthony "Tony" Moiso is the chief executive of Rancho Mission Viejo. He developed the 5,000-acre Rancho Santa Margarita in the mid-1980s. Since 1985, Rancho Mission Viejo has opened the Rancho Santa Margarita, Las Flores, and Ladera Ranch communities. (Courtesy of Rancho Mission Viejo.)

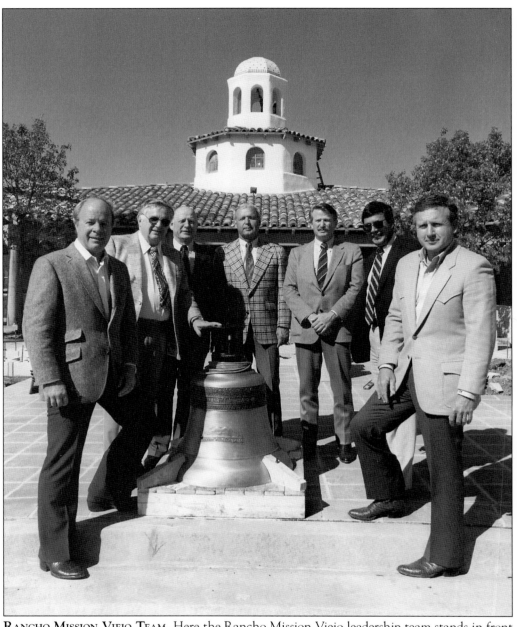

RANCHO MISSION VIEJO TEAM. Here the Rancho Mission Viejo leadership team stands in front of the Rancho Santa Margarita Information Center. Pictured from left to right are Tom Blum, Richard J. O'Neill, Bill Shattuck, Gilbert Aguirre, Jerome Moiso, Dana Empringham, and Anthony Moiso. (Courtesy of Rancho Mission Viejo.)

Four

THE DEVELOPMENT OF AN URBAN VILLAGE AND THE CITY TODAY

THE ORIGINAL VISION. Master planner and urban designer Richard Reese, a key figure in the community's development, shared the following vision statement, which was written during the initial master planning and urban design process: "It is possible to create an Urban Village in an open space setting in such a manner that people will have the opportunity to live more open, communicative, nurturing, fully expressed lifestyles; reaching beyond the mere satisfaction of basic human needs for air, water, food, shelter, safety and economic opportunity; embracing wellness, well-being, self-expression and participative self-governance as normal, everyday living experiences." This vision is apparent throughout the photographs of structures found in this chapter. (Courtesy of Richard Reese and the Rancho Santa Margarita Historical Society.)

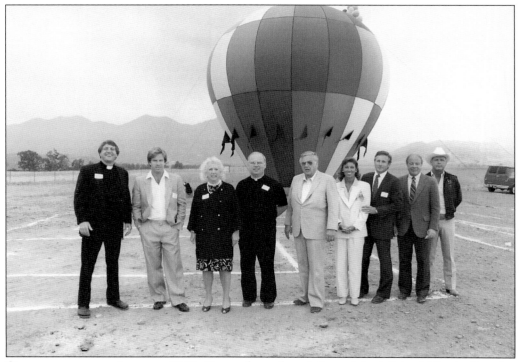

GROUNDBREAKING, AROUND 1985. Pictured are, from left to right, Michael Harris, Douglas Avery, Alice O'Neill Avery, an unidentified priest, Richard J. O'Neill, Melinda Moiso, Anthony Moiso, Tom Blum, and Gilbert Aguirre. Harris was the founding principal of Santa Margarita Catholic High School. The other individuals represented Rancho Mission Viejo. (Courtesy of Rancho Mission Viejo.)

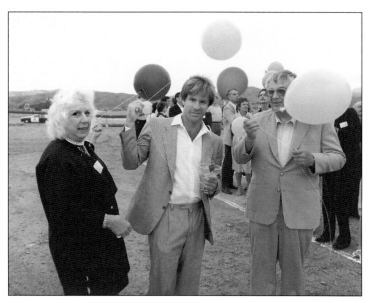

GROUNDBREAKING, AROUND 1985. Pictured are, from left to right, Alice O'Neill Avery, her son Douglas Avery, and her brother Richard J. O'Neill during the initial groundbreaking event. The master-planned communities would be built rapidly from the time that ground was originally broken. (Courtesy of Rancho Mission Viejo.)

GROUNDBREAKING, AROUND 1985. Pictured from left to right are Michael Harris, Alice O'Neill Avery, and Gilbert Aguirre during the initial groundbreaking ceremony. Harris was the principal of Mater Dei High School in Santa Ana before being asked by the Diocese of Orange to serve as the founding principal of Santa Margarita Catholic High School. (Courtesy Rancho Mission Viejo.)

ESTABLISHMENT OF ZIP CODE, 1986. To mark the occasion of having its own zip code, Gordon Rinehart and Buck Bean are delivering the first batch of mail by horseback. Included are letters from Pres. Ronald Reagan and Gov. George Deukmejian. Pictured from left to right are Gordon Rinehart, Elizabeth Wetserby, Anthony Moiso, Alice O'Neill Avery, Evelyn McNutt, and Buck Bean. (Courtesy of Rancho Mission Viejo.)

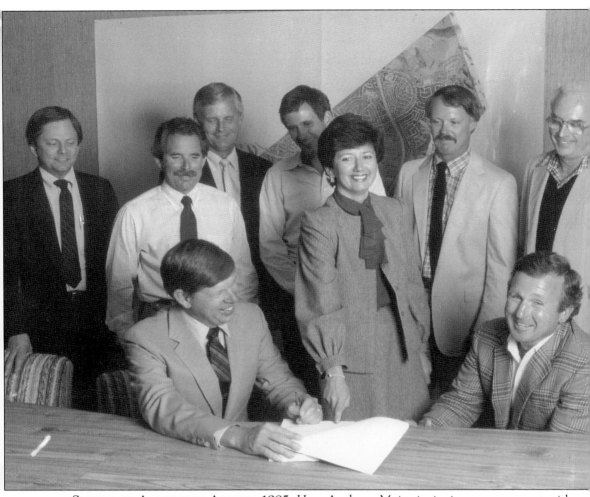

SIGNING OF AGREEMENT, AROUND 1985. Here Anthony Moiso is signing an agreement with a developer. Rancho Santa Margarita would be one of numerous major communities that Rancho Mission Viejo would open over an approximate 15-year span. (Courtesy of Rancho Mission Viejo.)

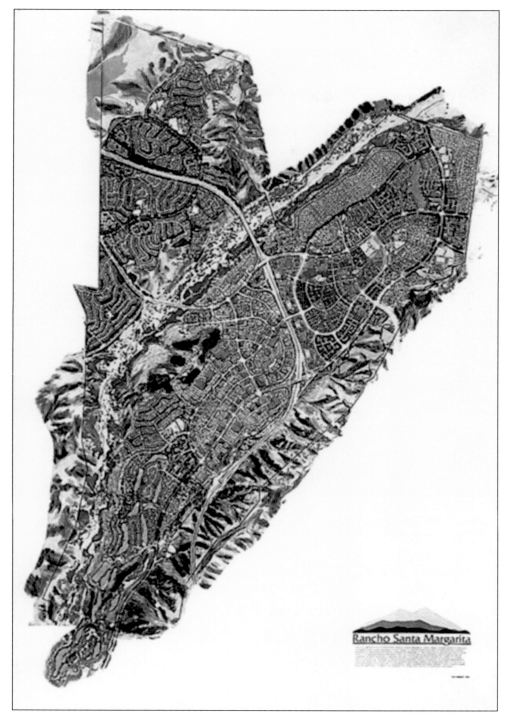

MASTER PLAN. This drawing depicts the original master plan of the community, which was designed to serve as an urban village nestled in southeast Orange County. (Courtesy of Richard Reese and the Rancho Santa Margarita Historical Society.)

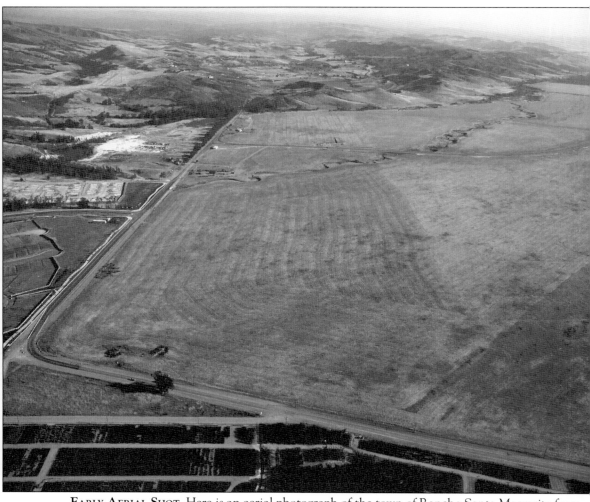

EARLY AERIAL SHOT. Here is an aerial photograph of the town of Rancho Santa Margarita from November 1985. This is what the area looked like nearly six months after ground was broken on the plain. (Courtesy of Rancho Mission Viejo.)

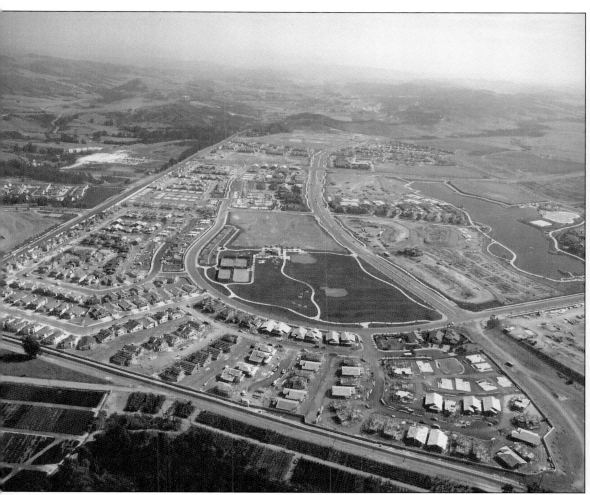

EARLY AERIAL SHOT. In this photograph from September 1986, note the progress of development in less than a year. (Courtesy of Rancho Mission Viejo.)

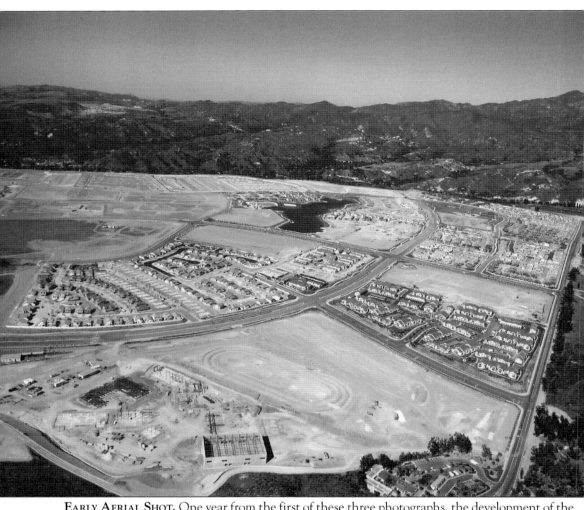

Early Aerial Shot. One year from the first of these three photographs, the development of the master-planned community is nearing completion. (Courtesy of Rancho Mission Viejo.)

THE INFORMATION CENTER. The Rancho Santa Margarita Information Center was established when the town was first developed. People interested in moving to the city could obtain information on types of housing tracts, pricing directions, and other amenities that the town would offer. The town was marketed as family-friendly with an abundance of parks and master-planned communities and the quality of life of a small village. (Courtesy of Rancho Mission Viejo.)

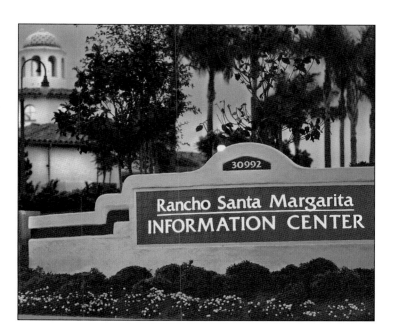

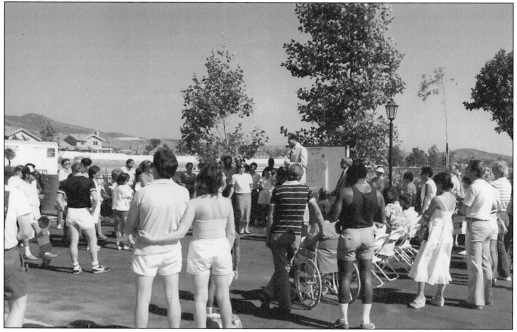

INFORMATION SESSIONS. As new tracts were opening, large information sessions were held to promote the area to prospective buyers. The sessions included model home tours, presentations, and question-and-answer sessions. (Courtesy of Rancho Mission Viejo.)

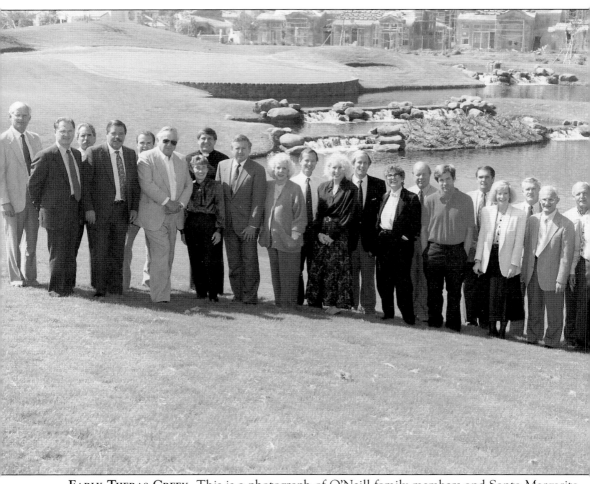

EARLY TIJERAS CREEK. This is a photograph of O'Neill family members and Santa Margarita Company staff members posing at the Tijeras Creek Golf Course. The public course was designed by Ted Robinson and measures 6,918 yards from the back tees. The 16th hole was once voted one if the best 18 holes in Southern California by the members of the Southern California PGA. (Courtesy of Rancho Mission Viejo.)

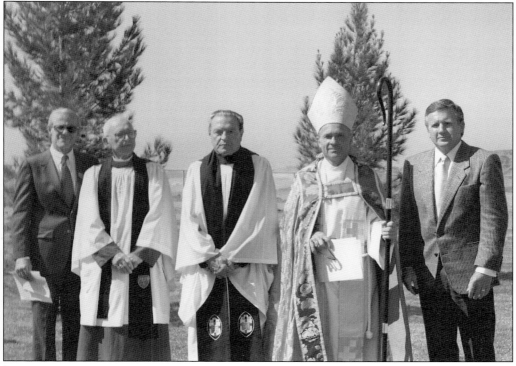

DEDICATION OF SANTA MARGARITA CATHOLIC HIGH SCHOOL. The opening of Santa Margarita Catholic High School practically coincided with the formation of the town. In these pictures, the land is dedicated. (Both courtesy of Rancho Mission Viejo.)

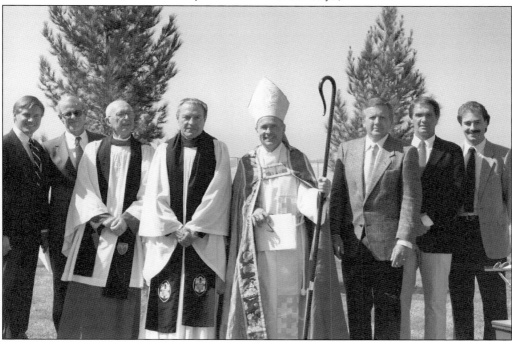

117

SANTA MARGARITA CATHOLIC HIGH SCHOOL. The school opened in the fall of 1987 and the charter class graduated in June 1991. Today the school—under the oversight of the Diocese of Orange—has a coeducational enrollment of nearly 1,600 students.

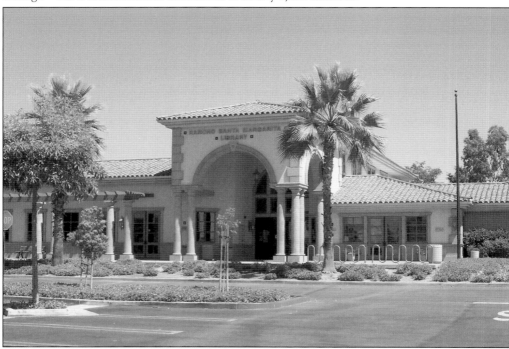

RANCHO SANTA MARGARITA LIBRARY. The Rancho Santa Margarita library is located near city hall, various stores, and restaurants.

118

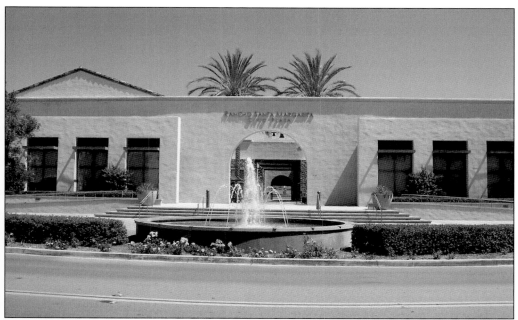

Rancho Santa Margarita Civic Plaza. The plaza contains city hall and a community service building. The structure is located in the heart of the city's dining and shopping area. Like many of the structures in the city, the plaza is built in a Spanish architectural style as a reflection of the area's long history.

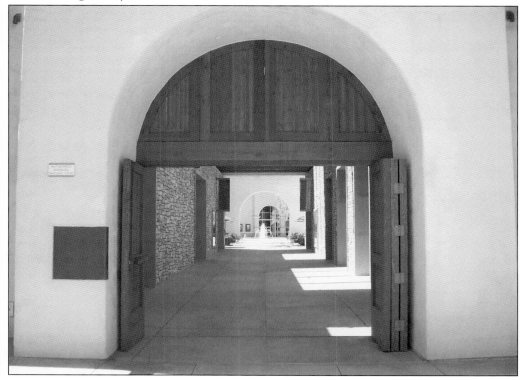

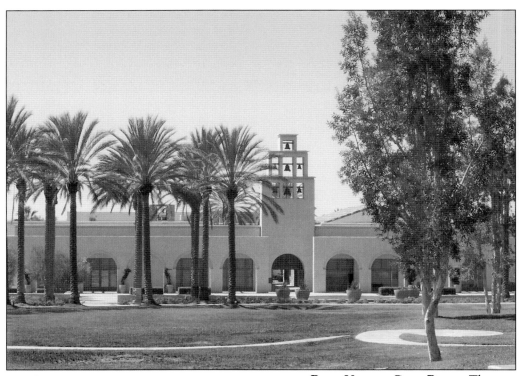

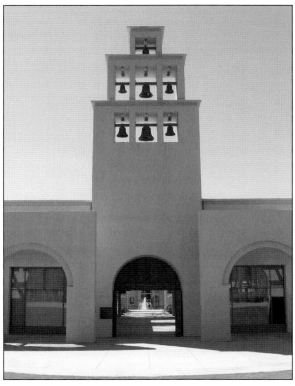

REAR VIEW OF CIVIC PLAZA. The Bell Tower Foundation, a foundation serving the needs of southeast Orange County, is housed here, along with city hall, which includes the town's police station. The city's annual Labor Day 5K race begins and ends at Civic Plaza. The summer Taste of Rancho Santa Margarita Festival also occurs near this building.

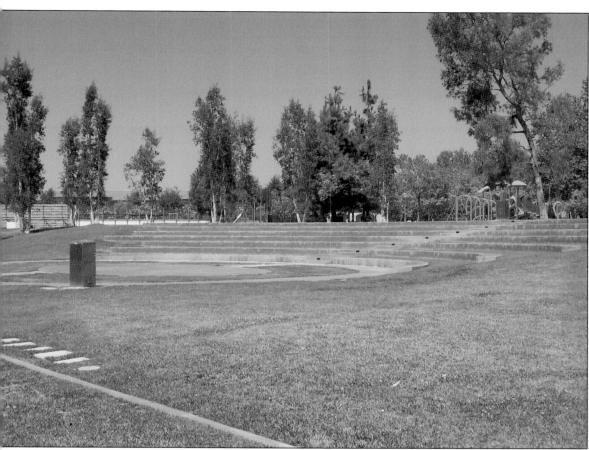

CENTRAL PARK AMPHITHEATRE. Behind the Civic Plaza lies Central Park, which includes this amphitheatre, enabling visitors to attend numerous performances by a variety of artists. The park is maintained by SAMLARC (Rancho Santa Margarita Landscape and Recreation Corporation), the city's largest homeowners' association.

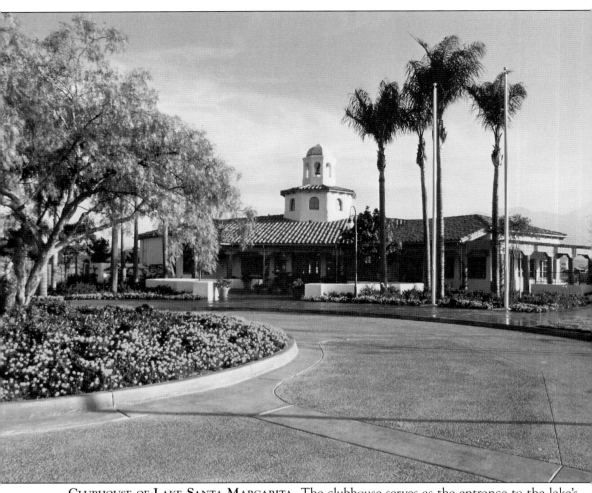

CLUBHOUSE OF LAKE SANTA MARGARITA. The clubhouse serves as the entrance to the lake's beach club. Like Civic Plaza, the clubhouse has a functioning bell tower.

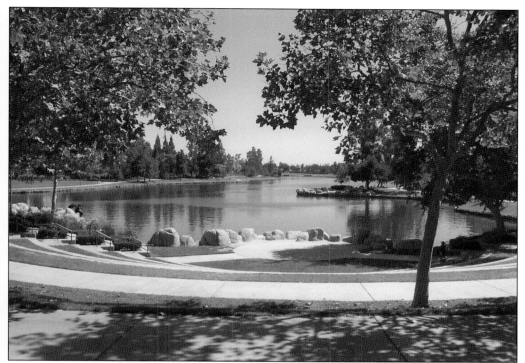

LAKE SANTA MARGARITA. With the Saddleback Mountains as a backdrop, Lake Santa Margarita is one of the most scenic lakes in Orange County. The circumference of the man-made lake is exactly 1 mile, making the shoreline a location frequented by walkers and joggers. The lake is also a popular location for fishing.

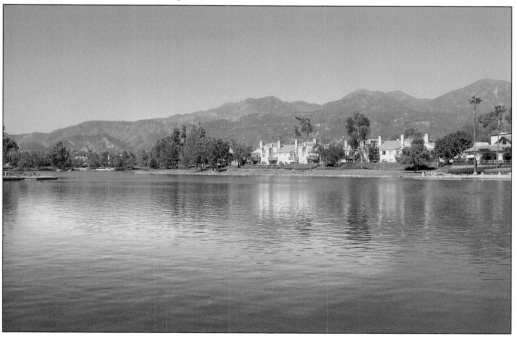

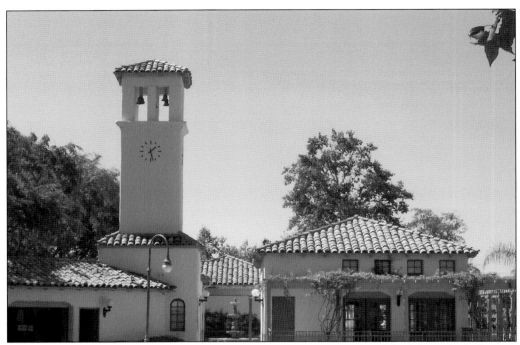

LAKE SANTA MARGARITA. These photographs depict two trademarks of the lake—the bell tower that overlooks the beach club and the various forms of wildlife that live around the lake. Visitors can observe ducks, geese, turtles, and various types of birds around and in the water.

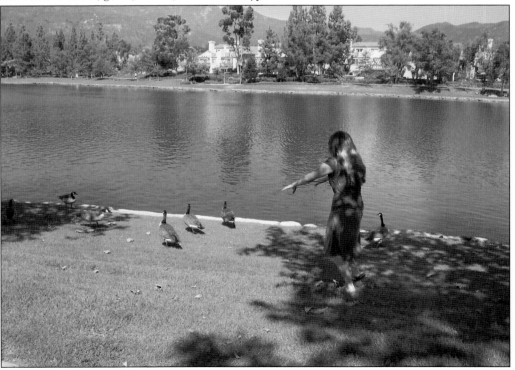

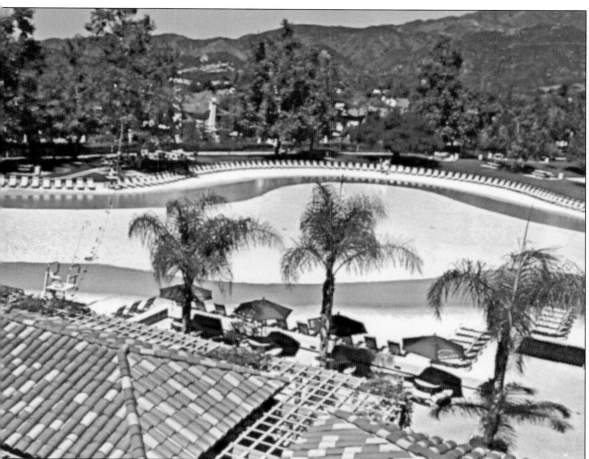

Lago Santa Margarita Beach Club. The beach club at the lake features a lagoon, picnic and barbeque areas, a sand volleyball court, boat rentals, and different types of wildlife. Today the beach club is one of the most popular destinations in the city and a favorite among locals. The greater lake is also the home of the annual Independence Day fireworks show. (Courtesy of Richard Reese and the Rancho Santa Margarita Historical Society.)

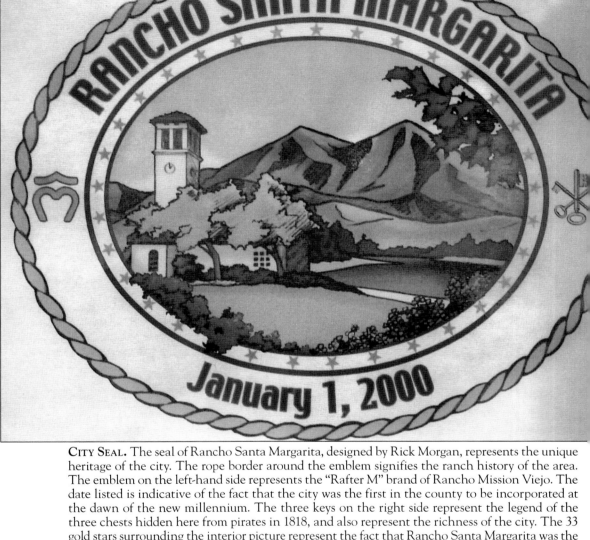

CITY SEAL. The seal of Rancho Santa Margarita, designed by Rick Morgan, represents the unique heritage of the city. The rope border around the emblem signifies the ranch history of the area. The emblem on the left-hand side represents the "Rafter M" brand of Rancho Mission Viejo. The date listed is indicative of the fact that the city was the first in the county to be incorporated at the dawn of the new millennium. The three keys on the right side represent the legend of the three chests hidden here from pirates in 1818, and also represent the richness of the city. The 33 gold stars surrounding the interior picture represent the fact that Rancho Santa Margarita was the 33rd city of Orange County. The beach club of Lake Santa Margarita is located toward the left, with a bell tower featured to represent the recurring Spanish-style architecture. A Jacaranda tree is located in front of the beach club, and the Saddleback Mountains are located in the backdrop. The plants toward the bottom center are bougainvillea—a tribute to the plants of the Rancho Santa Margarita y Las Flores and Rancho Mission Viejo. The shamrocks toward the center at right celebrate the Irish heritage of ranch founders Richard O'Neill Sr. and James Flood. Finally, a sycamore tree is located toward the right side. Rancho Santa Margarita has the longest city name in the state of California.

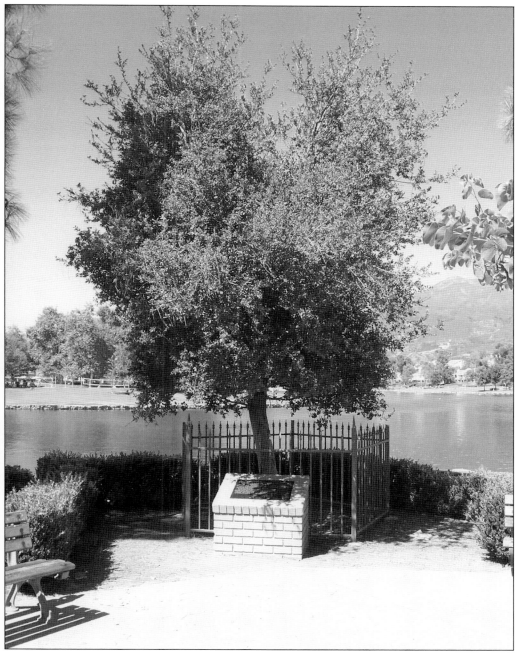

LISA FROST MEMORIAL. On September 11, 2001, Rancho Santa Margarita resident Lisa Frost was aboard United Airlines Flight 175, which was hijacked and crashed into the South Tower of the World Trade Center. She graduated summa cum laude and as valedictorian from Boston University in Hospitality Administration and Communication. She was also awarded the Scarlet Key from the university for her extraordinary achievement. The plaque in front of this tree states, "This tree is planted in her memory and is dedicated to parents who have children who are with God in Heaven."

www.arcadiapublishing.com

Discover books about the town where you grew up, the cities where your friends and families live, the town where your parents met, or even that retirement spot you've been dreaming about. Our Web site provides history lovers with exclusive deals, advanced notification about new titles, e-mail alerts of author events, and much more.

MADE IN THE

Arcadia Publishing, the leading local history publisher in the United States, is committed to making history accessible and meaningful through publishing books that celebrate and preserve the heritage of America's people and places. Consistent with our mission to preserve history on a local level, this book was printed in South Carolina on American-made paper and manufactured entirely in the United States.

This book carries the accredited Forest Stewardship Council (FSC) label and is printed on 100 percent FSC-certified paper. Products carrying the FSC label are independently certified to assure consumers that they come from forests that are managed to meet the social, economic, and ecological needs of present and future generations.

FSC

Mixed Sources
Product group from well-managed forests and other controlled sources

Cert no. SW-COC-001530
www.fsc.org
© 1996 Forest Stewardship Council

Find Your Place in History.